Francis Frith's
Around Camberley

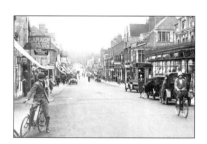

Photographic Memories

Francis Frith's
Around Camberley

Ken Clarke

FRITH
BOOK Co

Paperback edition published in the United Kingdom in 2000 by
Frith Book Company Ltd

British Library Cataloguing in Publication Data

Francis Frith's Around Camberley
Ken Clarke
ISBN 1-85937-222-8

Frith Book Company Ltd
Frith's Barn, Teffont,
Salisbury, Wiltshire SP3 5QP
Tel: +44 (0) 1722 716 376
Email: info@frithbook.co.uk
www.frithbook.co.uk

Printed and bound in Great Britain

Front Cover: Camberley, High Street 79600

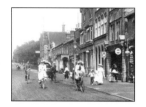

Contents

Francis Frith: *Victorian Pioneer*

FRANCIS FRITH, Victorian founder of the world-famous photographic archive, was a complex and multitudinous man. A devout Quaker and a highly successful Victorian businessman, he was both philosophic by nature and pioneering in outlook.

By 1855 Francis Frith had already established a wholesale grocery business in Liverpool, and sold it for the astonishing sum of £200,000, which is the equivalent today of over £15,000,000. Now a multi-millionaire, he was able to indulge his passion for travel. As a child he had pored over travel books written by early explorers, and his fancy and imagination had been stirred by family holidays to the sublime mountain regions of Wales and Scotland. 'What a land of spirit-stirring and enriching scenes and places!' he had written. He was to return to these scenes of grandeur in later years to 'recapture the thousands of vivid and tender memories', but with a different purpose. Now in his thirties, and captivated by the new science of photography, Frith set out on a series of pioneering journeys to the Nile regions that occupied him from 1856 until 1860.

Intrigue and Adventure

He took with him on his travels a specially-designed wicker carriage that acted as both dark-room and sleeping chamber. These far-flung journeys were packed with intrigue and adventure. In his life story, written when he was sixty-three, Frith tells of being held captive by bandits, and of fighting 'an awful midnight battle to the very point of surrender with a deadly pack of hungry, wild dogs'. Sporting flowing Arab costume, Frith arrived at Akaba by camel seventy years before Lawrence, where he encountered 'desert princes and rival sheikhs, blazing with jewel-hilted swords'.

During these extraordinary adventures he was assiduously exploring the desert regions bordering the Nile and patiently recording the antiquities and peoples with his camera. He was the first photographer to venture beyond the sixth cataract. Africa was still the mysterious 'Dark Continent', and Stanley and Livingstone's historic meeting was a decade into the future. The conditions for picture taking confound belief. He laboured for hours in his wicker dark-room in the sweltering heat of the desert, while the volatile chemicals fizzed dangerously in their trays. Often he was forced to work in remote tombs and caves where conditions were cooler. Back in London he exhibited his photographs and was

'rapturously cheered' by members of the Royal Society. His reputation as a photographer was made overnight. An eminent modern historian has likened their impact on the population of the time to that on our own generation of the first photographs taken on the surface of the moon.

Venture of a Life-Time

Characteristically, Frith quickly spotted the opportunity to create a new business as a specialist publisher of photographs. He lived in an era of immense and sometimes violent change. For the poor in the early part of Victoria's reign work was a drudge and the hours long, and people had precious little free time to enjoy themselves. Most had no transport other than a cart or gig at their disposal, and had not travelled far beyond the

boundaries of their own town or village. However, by the 1870s, the railways had threaded their way across the country, and Bank Holidays and half-day Saturdays had been made obligatory by Act of Parliament. All of a sudden the ordinary working man and his family were able to enjoy days out and see a little more of the world.

With characteristic business acumen, Francis Frith foresaw that these new tourists would enjoy having souvenirs to commemorate their days out. In 1860 he married Mary Ann Rosling and set out with the intention of photographing every city, town and village in Britain. For the next thirty years he travelled the country by train and by pony and trap, producing fine photographs of seaside resorts and beauty spots that were keenly bought by millions of Victorians. These prints were painstakingly pasted into family albums and pored over during the dark nights of winter, rekindling precious memories of summer excursions.

The Rise of Frith & Co

Frith's studio was soon supplying retail shops all over the country. To meet the demand he gathered about him a small team of photographers, and published the work of independent artist-photographers of the calibre of Roger Fenton and Francis Bedford. In order to gain some understanding of the scale of Frith's business one only has to look at the catalogue issued by Frith & Co in 1886: it runs to some 670 pages, listing not only many thousands of views of the British Isles but also many photographs of most European countries, and China, Japan, the USA and

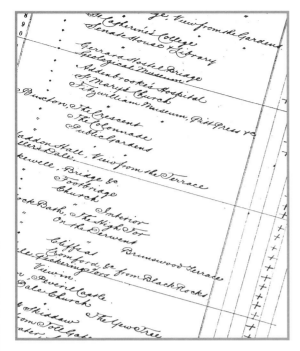

Canada – note the sample page shown above from the hand-written *Frith & Co* ledgers detailing pictures taken. By 1890 Frith had created the greatest specialist photographic publishing company in the world, with over 2,000 outlets – more than the combined number that Boots and W H Smith have today! The picture on the right shows the *Frith & Co* display board at Ingleton in the Yorkshire Dales. Beautifully constructed with mahogany frame and gilt inserts, it could display up to a dozen local scenes.

Postcard Bonanza

The ever-popular holiday postcard we know today took many years to develop. In 1870 the Post Office issued the first plain cards, with a pre-printed stamp on one face. In 1894 they allowed other publishers' cards to be sent through the mail with an attached adhesive halfpenny stamp. Demand grew rapidly, and in 1895 a new size of postcard was permitted called the court card, but there was little room for illustration. In 1899, a year after Frith's death, a new card measuring 5.5 x 3.5 inches became the standard format, but it was not until 1902 that the divided back came into being, with address and message on one face and a full-size illustration on the other. *Frith & Co* were in the vanguard of postcard development, and Frith's sons Eustace and Cyril continued their father's monumental task, expanding the number of views offered to the public and recording more and more places in Britain, as the coasts and countryside were opened up to mass travel.

Francis Frith died in 1898 at his villa in Cannes, his great project still growing. The archive he created continued in business for another seventy years. By 1970 it contained over a third of a million pictures of 7,000 cities, towns and villages. The massive photographic record Frith has left to us stands as a living monument to a special and very remarkable man.

Frith's Archive: *A Unique Legacy*

FRANCIS FRITH'S legacy to us today is of immense significance and value, for the magnificent archive of evocative photographs he created provides a unique record of change in 7,000 cities, towns and villages throughout Britain over a century and more. Frith and his fellow studio photographers revisited locations many times down the years to update their views, compiling for us an enthralling and colourful pageant of British life and character.

We tend to think of Frith's sepia views of Britain as nostalgic, for most of us use them to conjure up memories of places in our own lives with which we have family associations. It often makes us forget that to Francis Frith they were records of daily life as it was actually being lived in the cities, towns and villages of his day. The Victorian age was one of great and often bewildering change for ordinary people, and though the pictures evoke an impression of slower times, life was as busy and hectic as it is today.

We are fortunate that Frith was a photographer of the people, dedicated to recording the minutiae of everyday life. For it is this sheer wealth of visual data, the painstaking chronicle of changes in dress, transport, street layouts, buildings, housing, engineering and landscape that captivates us so much today. His remarkable images offer us a powerful link with the past and with the lives of our ancestors.

Today's Technology

Computers have now made it possible for Frith's many thousands of images to be accessed almost instantly. In the Frith archive today, each photograph is carefully 'digitised' then stored on a CD Rom. Frith archivists can locate a single photograph amongst thousands within seconds. Views can be catalogued and sorted under a variety of categories of place and content to the immediate benefit of researchers.

Inexpensive reference prints can be created for them at the touch of a mouse button, and a wide range of books and other printed materials assembled and published for a wider, more general readership - in the next twelve months over a hundred Frith local history titles will be published! The day-to-day workings of the archive are very different from how they were in Francis Frith's time: imagine the herculean task of sorting through eleven tons of glass negatives as Frith had to do to locate a particular

See Frith at www. frithbook.co.uk

sequence of pictures! Yet the archive still prides itself on maintaining the same high standards of excellence laid down by Francis Frith, including the painstaking cataloguing and indexing of every view.

It is curious to reflect on how the internet now allows researchers in America and elsewhere greater instant access to the archive than Frith himself ever enjoyed. Many thousands of individual views can be called up on screen within seconds on one of the Frith internet sites, enabling people living continents away to revisit the streets of their ancestral home town, or view places in Britain where they have enjoyed holidays. Many overseas researchers welcome the chance to view special theme selections, such as transport, sports, costume and ancient monuments.

We are certain that Francis Frith would have heartily approved of these modern developments in imaging techniques, for he himself was always working at the very limits of Victorian photographic technology.

The Value of the Archive Today

Because of the benefits brought by the computer, Frith's images are increasingly studied by social historians, by researchers into genealogy and ancestory, by architects, town planners, and by teachers and schoolchildren involved in local history projects.

In addition, the archive offers every one of us an opportunity to examine the places where we and our families have lived and worked down the years. Highly successful in Frith's own era, the archive is now, a century and more on, entering a new phase of popularity.

The Past in Tune with the Future

Historians consider the Francis Frith Collection to be of prime national importance. It is the only archive of its kind remaining in private ownership and has been valued at a million pounds. However, this figure is now rapidly increasing as digital technology enables more and more people around the world to enjoy its benefits.

Francis Frith's archive is now housed in an historic timber barn in the beautiful village of Teffont in Wiltshire. Its founder would not recognize the archive office as it is today. In place of the many thousands of dusty boxes containing glass plate negatives and an all-pervading odour of photographic chemicals, there are now ranks of computer screens. He would be amazed to watch his images travelling round the world at unimaginable speeds through network and internet lines.

The archive's future is both bright and exciting. Francis Frith, with his unshakeable belief in making photographs available to the greatest number of people, would undoubtedly approve of what is being done today with his lifetime's work. His photographs, depicting our shared past, are now bringing pleasure and enlightenment to millions around the world a century and more after his death.

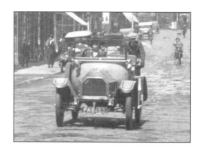

Around Camberley - *An Introduction*

CAMBERLEY IS NOT an old town, unlike Farnham and Guildford, its neighbours, both of which have a long history and castles and other old buildings which tell their story. Indeed, its name did not appear until 1877. It would appear that the area did experience the echo of marching Romans as they made their way to Easthampstead, and a Roman coin was unearthed on Diamond Hill. The name of Portesbery is alleged to have derived from a mound or hill which the Romans may have occupied en route for Easthampstead. According to George Poulter, in 1782 a lad ploughing land at Rapley's Farm, towards Bagshot, found a Roman earthenware jar.

After telling his boss, a Mr Handasyd, the plough was set to double the usual depth and many more vessels were turned up, but none were whole.

Chertsey Abbey, founded in 666, included Frimley in the monastic estate. In the 12th century, the list of chapels within the possession of the Abbey included those chapels of Frimley and Henley, near Ash, in Surrey. The name of Frimley is thought to have derived from the personal name of Fremma or Fremle, or it may have come from the Scandinavian name for stranger, Fremmed. Over the years there have been many alternative ways of spelling its name: Fremelsworth, Fremleigh, Fremeley, Frymley and

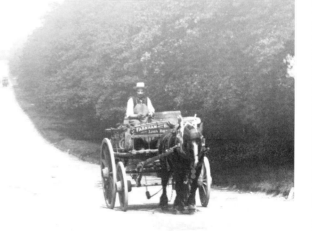

Frymeley. It would appear that it was not until 1575 that the first reference to Frimley was made.

On 19 May 1553, Queen Mary granted the manor of Frimley to John White of Aldershot, who later became Lord Mayor of London. After his death the manor passed into the Tichborne family, where it remained for six generations. When James I became King, he ordered his surveyor to survey the boundaries of Windsor Forest and the walks, which up to then were unknown. This task, undertaken by John Norden, was completed in 1607, and the subsequent maps were called Norden's Survey. Frimley, which was outside the Forest, was referred to as Frimley Walke, and consisted of some 7,768 acres of land.

The area now occupied by Camberley, mainly heather-clad common and pine trees, was part of the Bagshot Heath, and proved extremely popular with highwaymen, who would rob the mail coaches which crossed the heath while en route to and from London. Whether Dick Turpin ever worked this area is open to conjecture, but one of the most infamous highwaymen was William Davis. He was born at Wrexham in 1627, and married the daughter of an innkeeper in Gloucestershire, before moving to Bagshot to run a farm. He had 18 children and grew fond of the Exeter coaches and their passengers, who provided him with rich pickings. He would always pay his debts in gold coin of the realm, and because of this he became known as the Golden Farmer. The Mongolian Barbeque was formerly the Jolly Farmer inn, and prior to 1823 was called the Golden Farmer, after William Davis. His life-style proved profitable, and he opened a shop in London; but he still carried on with his old habits. After the murder of one of his victims, he was found guilty and was hanged at Salisbury Court in London in December 1690. His body was bought down to Bagshot and gibbeted in front of his house. Another notable robber was Claude du Vall, who came over from France at the time of the Reformation. He was captured in London and hanged at Tyburn in 1670, aged 27 years, and is buried in the middle aisle of Covent Garden Church.

To find out what the area was like in the 18th century we have to read Daniel Defoe, who in 1724 described Bagshot Heath as 'a vast tract of land, some of it within 17 or 18 miles of the capital city, which is horrid and frightful to look at, not only good for little, but good for nothing, much of it a sandy desert and one may frequently be put in mind of the Arabia deserts'. This is verified by that well-known writer William Cobbett from Farnham, who 100 years later in his

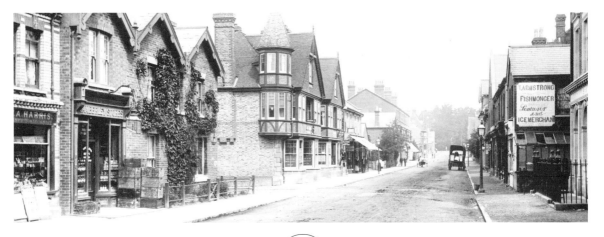

book 'Rural Rides' wrote: 'great numbers have seen the wide sweep of barrenness which exhibits itself between the Golden Farmer and Blackwater'. It would appear that the Heath was not an attractive place, and if you travelled across there was the risk of meeting those rather nasty highwaymen, who would quickly relieve you of your valuables and money.

At the end of the 18th century there were only about 100 inhabitants; the only settlements were some inns, as well as some isolated cottages and farms. At the beginning of the 19th century, something occurred which was really the reason for the development of Camberley as a town: the opening of the Royal Military College, which moved here from Marlow, where it was founded in 1799 by HRH the Duke of York. Many people moved to the area, and houses and shops were built to accommodate them. This community was called Newtown, and it was not until 1831 that it was deemed necessary to change it to York Town, after the Duke of York, who founded the RMC. At this time there were only 702 people living in the whole of the Camberley area - 407 males and 295 females.

Fifty years later, the Staff College opened at the other end of the London Road, and this community was called Cambridge Town, after the Duke of Cambridge, who at that time was the Commander in Chief of the British Army. He had also laid the foundation stone of the College in 1859. Queen Victoria and Prince Albert took a keen interest in the building, and on 22 November 1861 they drove over from Windsor in the pouring rain to inspect the progress of the building works. On his return, Prince Albert complained of being tired, and died three weeks later of typhoid fever.

Cambridge Town continued to grow, and with this increase in population many postcards and letters were sent to the residents. Unfortunately, for them that is, the Post Office got confused; instead of being delivered to Cambridge Town, the mail was sent to Cambridge, and was thus delayed. This did not please the locals, and after much complaining from them, the Post Master General decided that the name of the town would have to change. On 15 January 1877 it was officially changed to Camberley. The commonly-held explanation for the name is that it was derived from Cam, after a small stream that flowed through the town, Ber, after Amber Hill, which was depicted on Norden's Survey, and Ley, meaning pasture land or shelter. So far this name has stuck, and is now used to describe the whole of what was Cambridge Town and York Town.

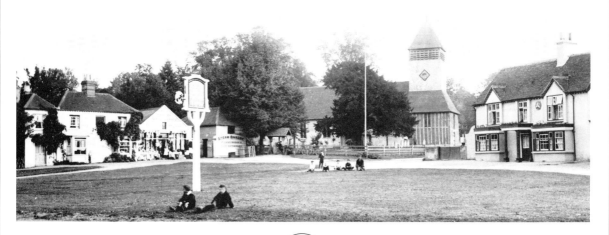

The railway arrived the following year; this, coupled with the fact that the area was fast becoming an ideal area for retired military officers to set up home in, meant that the population increased rapidly. One army magazine carried these words: 'for miles around there stretches a glorious expanse of hilly country, partly covered with pines, partly consisting of gorse and heather-clad common. The variety of walks and rides is infinite, and it is impossible to exhaust the charms of the scenery, which unfold in every direction. Altogether Camberley is a place hard to beat for those who are in doubt on where to set up their household goods on retirement'.

At the start of the 20th century, Camberley was a rather neat Victorian town, consisting of many retired military officers and their families; the local shops provided the type of service they were used to, and expected. In my youth there were many delivery boys on bicycles, delivering a variety of goods, like bread, meat and other groceries. At one time, in the 1950s, it was one of the most expensive towns to live in the south of the country, closely following Oxford and Winchester.

Like many other towns and villages, Camberley suffered during the First World War, and lost many of its young men, mostly in France. But afterwards its growth continued, and much new development took place, some of it erected by builders from the Bournemouth area. A new cottage hospital was built, and there were many clubs and societies to join and enjoy. Life was great again, but this mood was shattered in 1939 with the outbreak of the Second World War.

Six years later normality returned, and the town started to pick up the pieces. The main shopping area was the High Street, with the odd shop in Princess Street and Obelisk Street. Park Street mainly consisted of houses. More and more new houses were built to accommodate the many people who wished to live here, and in the 1950s the Old Dean Estate was begun to provide homes for local people. Later, the second phase was used to house some of the over-spill population from some of the outer London Boroughs. To provide work for these new residents, the Doman Road Industrial Estate was inaugurated; it still does the same job today, although since then there have been many more factories and small units built.

Growing up in Camberley during these times was exciting, and we had the choice of two cinemas, as well as youth clubs. I can well remember the furore that greeted the showing of

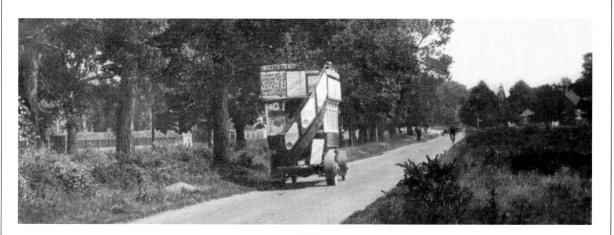

the first 'rock and roll' films. There were very few cars on the roads, and most children rode around on bicycles to travel to school or to see friends. Progress had to be maintained, and by the beginning of the 1970s it was decided that a new town centre had to be provided. To make way for it, many of the old Victorian cottages and shops that lay between the High Street and Park Street were demolished, and a new-look town centre was established. This is set to increase in the not-too-distant future with the development of the land west of Park Street. The Obelisk that stands on the Knoll behind the Council Offices has looked down on Camberley since its beginnings in 1750, but it will now view a much-altered town in the future. Whether this is an improvement or not is very much a matter for individual opinion, but the local elected representatives may wish to bear in mind these words written by Oliver Goldsmith: 'in my time the follies of the town crept slowly among us, but now they travel faster than a stagecoach'.

The first chapter concentrates on the High Street and the Staff College, beginning at the railway station, and the next chapter carries on down the London Road, and takes a look at York Town and the Royal Military Academy, Sandhurst. The final two chapters take in some of the villages surrounding Camberley, including those over the county borders in Hampshire and Berkshire, such as Hawley, Blackwater, Yateley and Sandhurst.

Camberley
and the Staff College

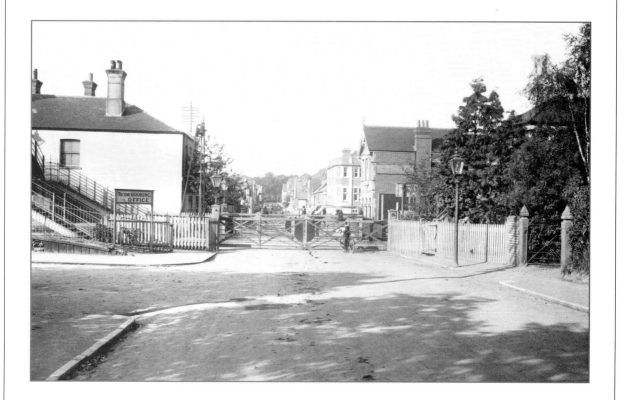

The Station 1908 61031
We are in Heathcote Road, looking down the High Street, with the grounds
of the Staff College visible in the background. The Station Master's house
can be seen to the left, with the main entrance to the station beyond that.
The closed gates would indicate the arrival of a steam train.

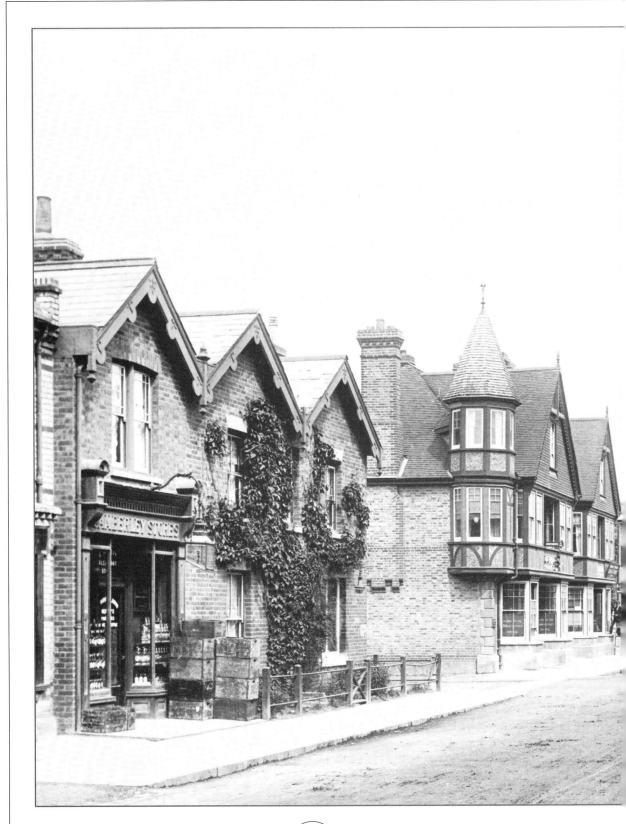

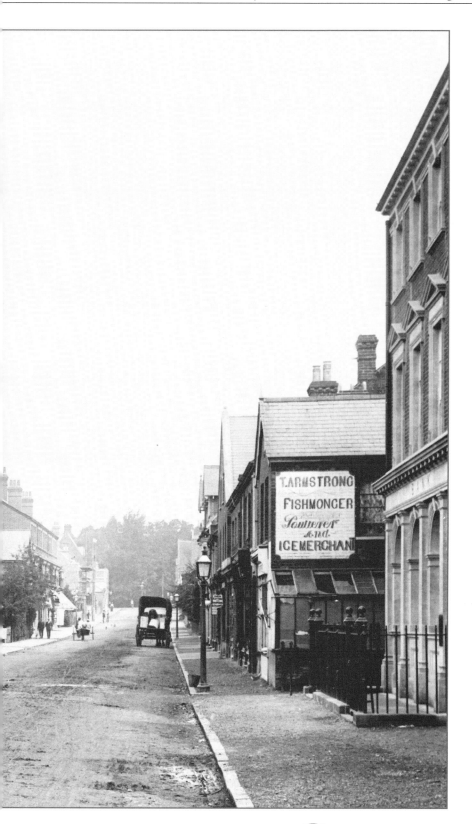

High Street 1901

46832

The bank on the right was Simonds Bank, opposite Princess Street, now called Princess Way. This led to School Lane, the home of the Camberley Infants and Primary Schools, which disappeared when the new town centre was constructed. The ivy-clad cottage next to the Camberley Stores was typical of the many cottages in the area.

▼ **High Street 1936** 87779

The wall on the right would be that of the Police Station, near the junction of the High Street with Portesbery Road. Just beyond the junction is Hankinson the estate agents, which is still the home to a firm of estate agents.

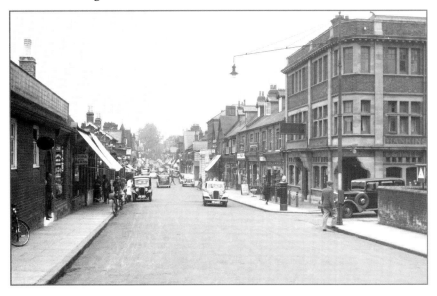

▼ **High Street 1909** 61461

It is eight years later than photograph No 46832, and not a lot has changed. Armstrong, the fishmonger and poulterer, was pulled down to make way for Knoll Walk. My late father could remember watching a worker plucking a live chicken; apparently the feathers come out more easily from a live bird.

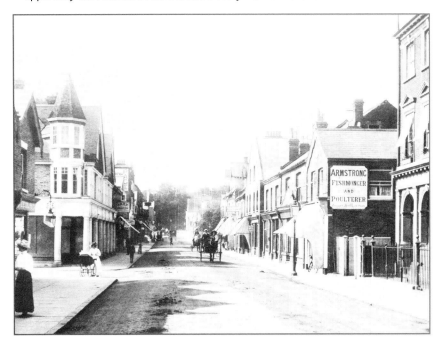

▲ **High Street 1927** 79600

The High Street, with many cars, and a tarmacadam road, is much changed from earlier pictures. Simonds Bank is now Barclays, and Armstrongs has become Eighteens. A tea-room has opened on the corner of Princess Street to cater for the increase in the population. The shops on the left have now made way for more modern blocks of shops and offices.

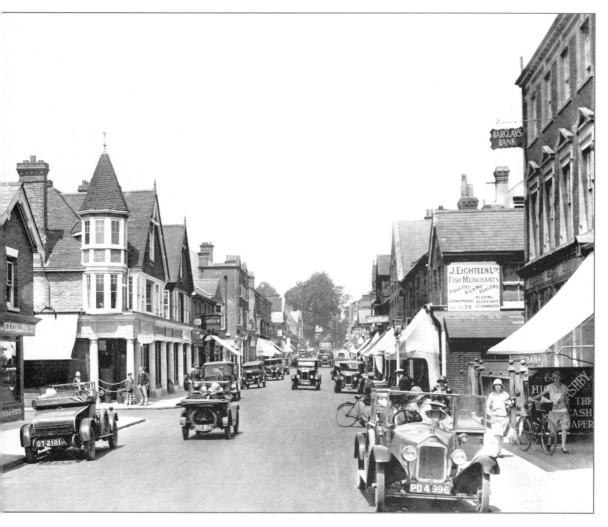

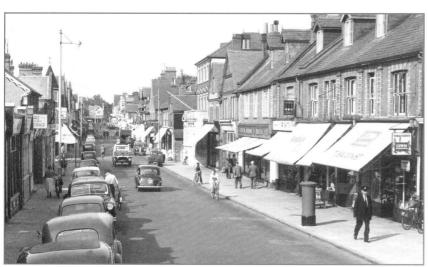

◄ **High Street c1955** C12086
The house at the top of this view was that of the Sergeant Major from the Staff College. There are a lot of shops now, and many of the houses that were first built have now altered to accommodate the increase in trade. Traffic travels both ways. Notice the Police Officer on his bicycle to the left, examining a parked vehicle.

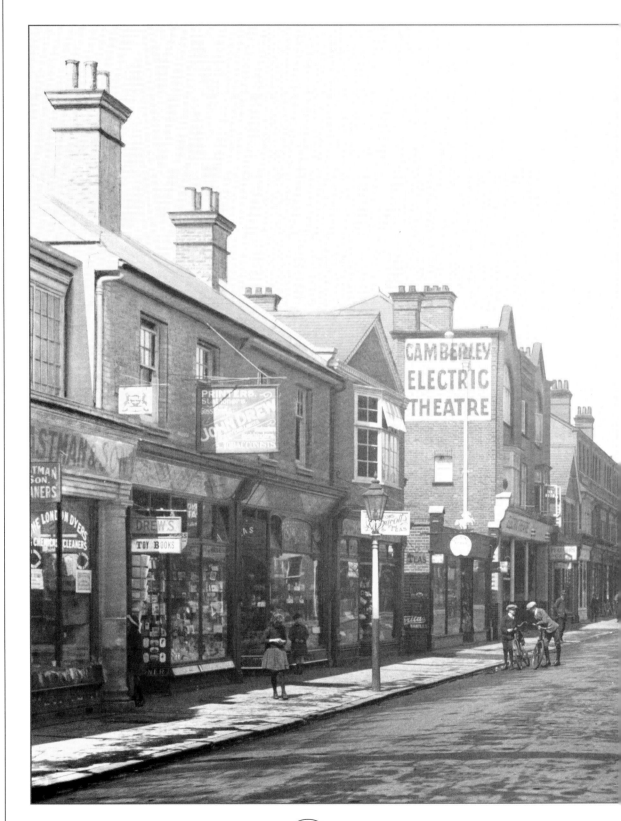

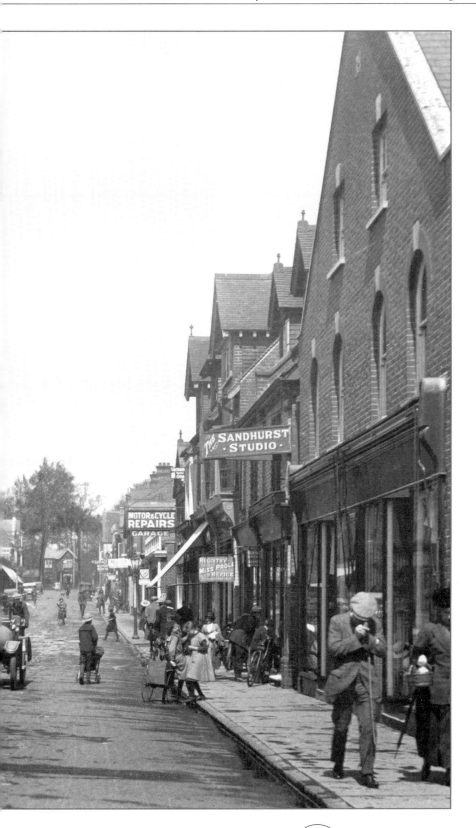

High Street 1919
68800

What a variety of shops there are to be seen! The first shop on the right is now W.H.Smith. The Electrical Theatre, which opened in 1910, is now the home of a building society. John Drew had many shops in the town, and used to publish his own postcards of the area. Miss Prole's shop on the right used to provide servants for the many large households requiring their services. Miss Prole was described as 'a tall majestic figure, with an awesome bust'.

▼ **High Street 1936** 87778A

We are now at the top of the High Street, looking from the London Road, with the Cambridge Hotel to our left, with the steps leading to the smoking room, which later became tea-rooms. Next but one to the Westminster Bank was Lucas, gents' outfitters, followed by J Pullars, which later became Eastmans Dyers and Cleaners. My late mother started work there in 1948, on a salary of £3 a week.

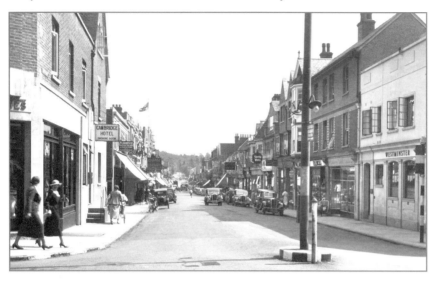

▼ **High Street c1965** C12085

This is a comparatively modern scene in the High Street, showing two-way traffic and a variety of cars. This picture clearly shows how the shop fronts were added on to the fronts of the houses, when the town grew in size to warrant more shops to cater for the needs of a larger population. At the top is the junction of Heatcote Road and Park Road.

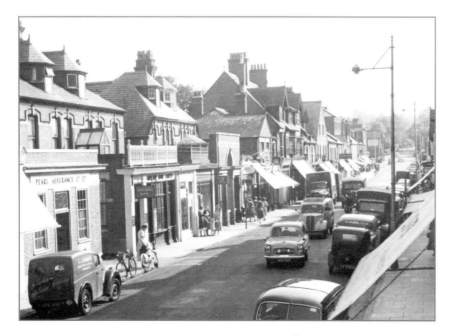

▲ **High Street 1906** 57179

We are now seeing a view looking towards the railway station, with many of these shops still in existence today, but with more modern shop fronts. Evans gave way to Boots, and Cousins ceased trading some years ago, after relocating to Park Street. St Georges Road is to the left, opposite Obelisk Street.

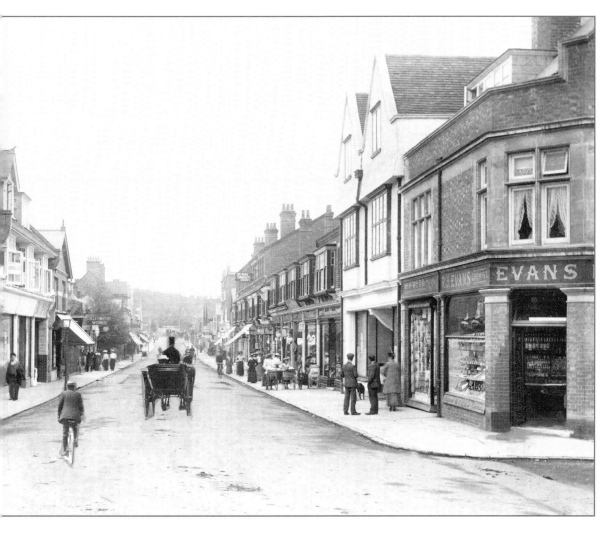

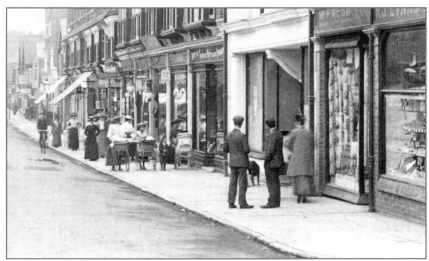

◀ **Extract from:**
High Street 1906 57179

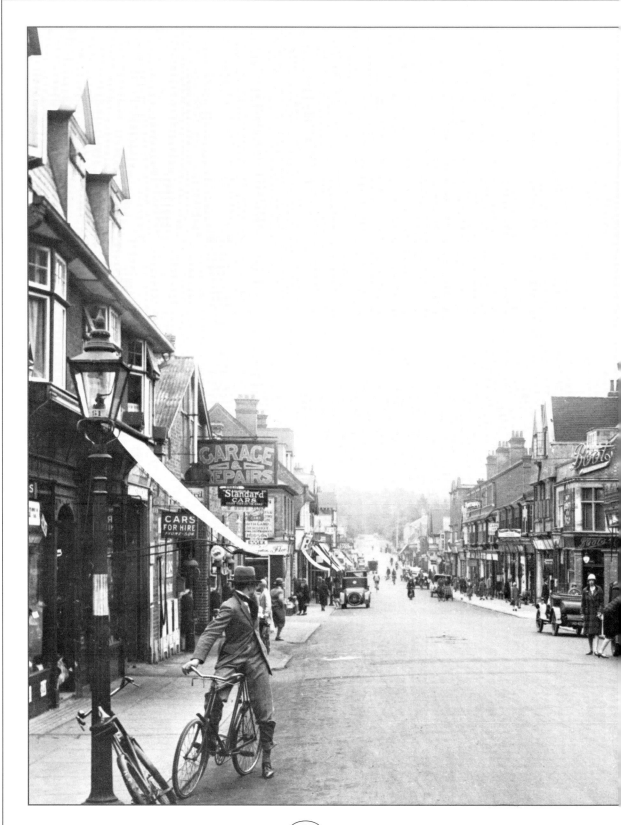

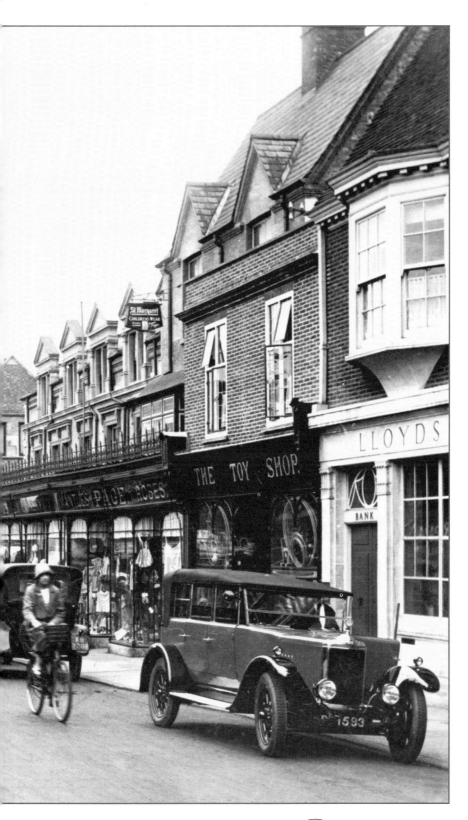

High Street 1925
78125
Solomon's Garage is to
the left, on the corner
of St Georges Road,
opposite Pages Store,
which later became part
of the Alders chain.
Again, we are looking
towards the railway
station, with Boots the
chemists on the corner
of Obelisk Street, now
called Obelisk Way.

▼ **High Street c1965** C12084

We are at the same junction as shown in photograph No 57179, but this time some 59 years later. Solomon's Showroom, allegedly built with a flat roof to accommodate helicopters, has been replaced by an office block. They sold petrol for many years, before running foul of safety regulations. Pearsons used to sell bags of broken biscuits for 6d, very popular with schoolchildren.

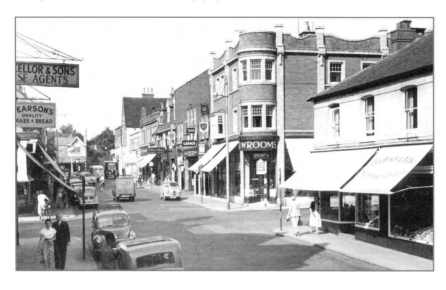

▼ **High Street c1955** C12028

We are a little closer to the railway station, and an Aldershot and District bus can be seen turning out of the bus station, now Pembroke Broadway. What was the Electric Theatre has now been converted into shops and offices. Notice the small windmill above the shop on the right of the picture.

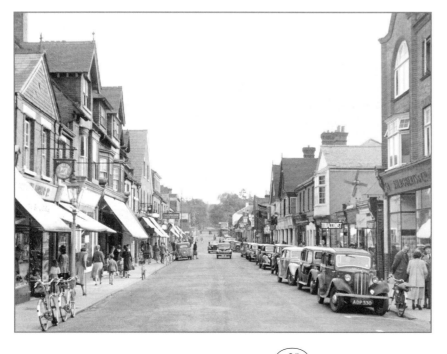

▲ **High Street 1925** 76693

We have turned round, and are now seeing the London Road at the end of the High Street. Boots has now replaced Evans, and Pages Store, which opened in 1909, is on the corner of Obelisk Street. His original shop was further down the High Street.

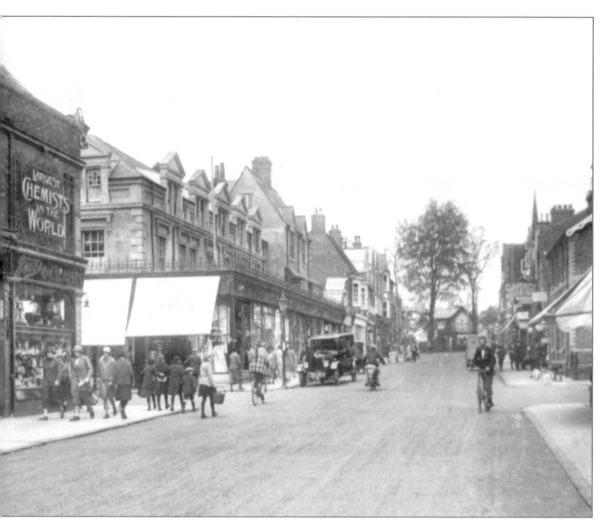

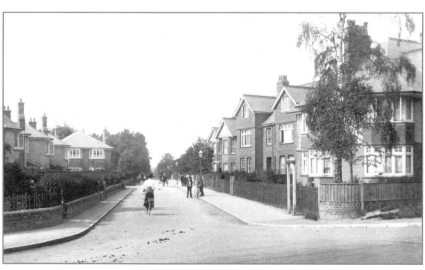

◀ **King's Ride 1909** 61465
Turning right at the top of the High Street into London Road, and taking the first road to the left, we find ourselves in King's Ride, which would take us onto Barossa Common. It was named King's Ride because King George III used to ride this way on his return to Windsor Castle. The first road to the right, York Road, was where Whites Garage had their workshops for many years, before moving to new premises.

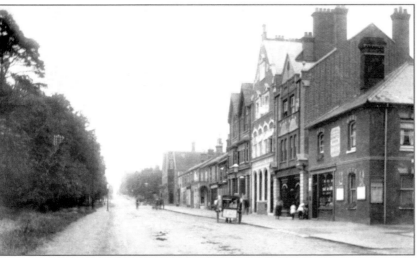

◀ **London Road 1901** 46834
Back into the London Road, we are now looking towards Bagshot, with the Cambridge Hotel the last building on the right. The tall building on the right, where the delivery vehicle is parked outside, is that of the London and Provincial Bank. The shop to its right became Smiths Garage, later changing to the Trustee Savings Bank. Next door, towards Bagshot, was the Post Office, run by Mr Norman, who also produced guides to the town.

◄ **Barossa, Old Dean Common 1931** 83859
At the end of Kings Ride we find the Barossa Common. It still looks the same today, although some of it has been used to build the extra houses which are needed to house the ever-increasing number of people who wish to reside in the area. On a cold and wet night, it would evoke the words of Daniel Defoe: 'land which is horrid and frightful to look at'.

▼ **London Road 1906** 57001
It is six years on from photograph No 46834, and the view has not changed much at all. Mr Sparvell's shop is the first on the right. He was an Alderman and a JP, and has a walk named after him, just down from where his shop was. The spire of St George's Church, built in 1892, can be seen just above the Cambridge Hotel. At one time I was in the choir, as was my father before me. It disappeared at the time of the new town centre.

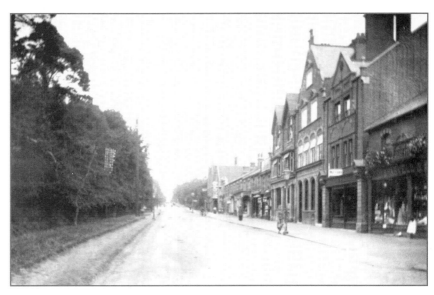

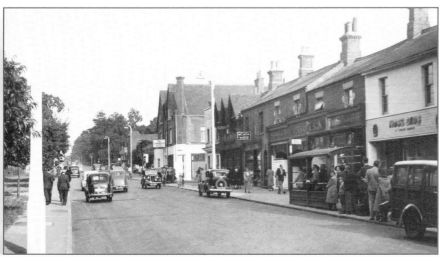

◄ **London Road c1955**
C12026
The Cambridge Hotel, on the corner of the High Street, was built in 1862 by Charles Raleigh Knight, and was named after the second Duke of Cambridge. Verran and Sons, fish and poultry purveyors, was a very popular shop, as was Betty Brown's Café, next door but one, where one could enjoy a cream tea served by smartly-dressed waitresses.

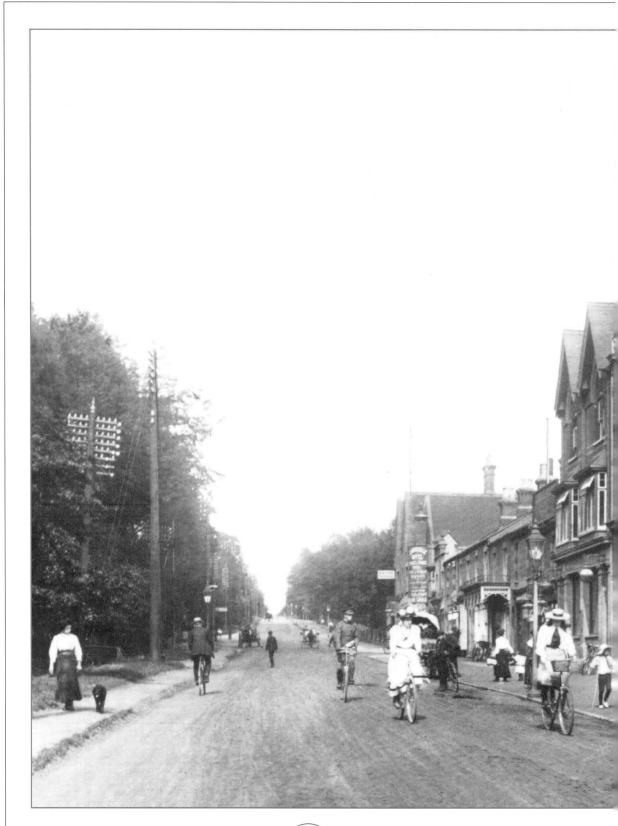

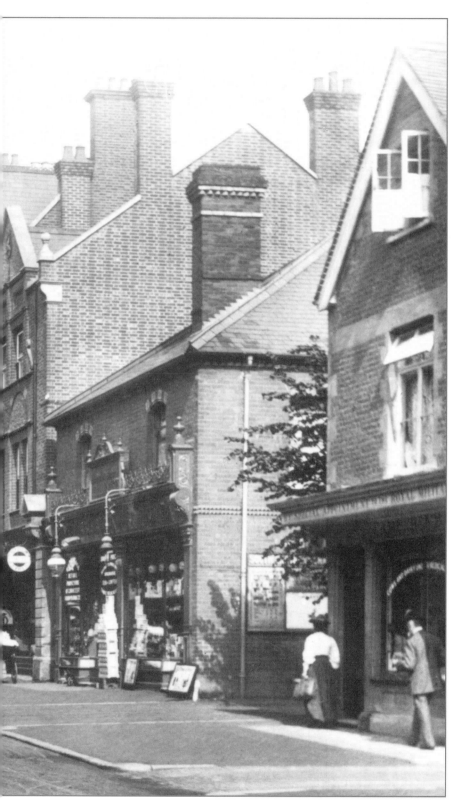

London Road 1909
61462
London Road and the High Street were the main shopping areas in the early 1900s. The roads were still made of compressed dirt, and motor vehicles were uncommon. The Cambridge Hotel, in the background, now boasts a large advertising board. This was the main road between London and the West Country.

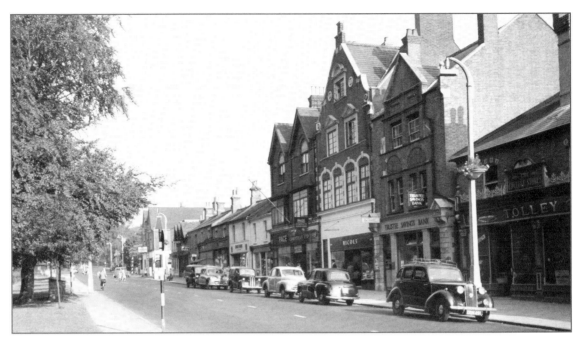

London Road c1955 C12104
To the left of the picture are the grounds of the Staff College; they were fully open to the public, who could enjoy the fine walks and sit by the lakes. Next to the Trustee Savings Bank is an alley, down which I used to go to school. It led into Obelisk Street. Tolley, the first shop, used to produce their own soft drinks on the premises.

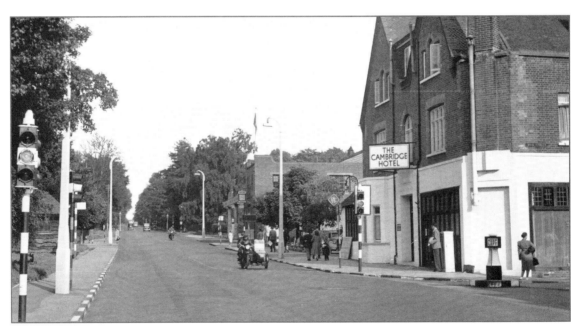

The Cambridge Hotel c1955 C12025
Traffic lights control the junction with the High Street, and the Hotel now boasts a car park. To the right one can just see the Cambridge Tea-Rooms, a smart place to have morning coffee or afternoon tea. Further up on the right is Whites Garage, with the clock outside. Following the demolition of the garage, the clock now adorns the outside of estate agents Chancellor and Sons in the High Street.

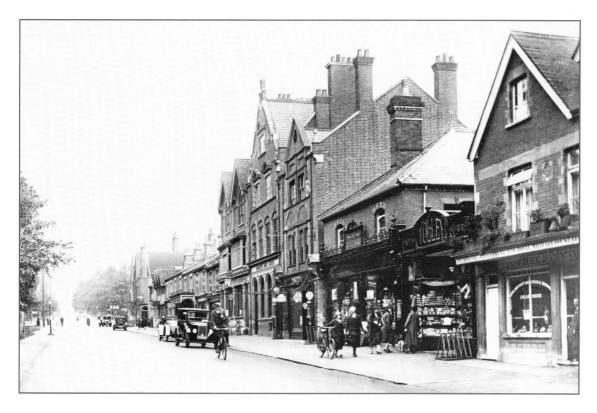

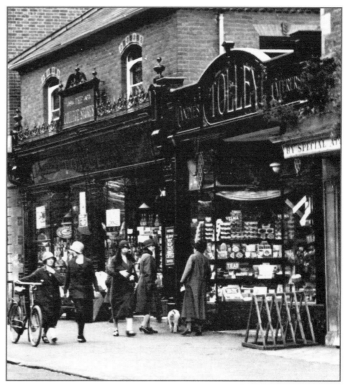

London Road 1925 78122
The town is changing, and Barclays Bank has replaced the London and Provincial, while Smiths Garage provides petrol from a pump. As can be seen, many of the shops were used by both of the Colleges for supplies and provisions.

▼ **The Congregational Church, Southwell Park Road 1931** 83854
Turning left into Park Street, we turn right into Southwell Park Road. The road on the left is Southern Road. The church was pulled down to make way for new development which did not take place, although at the present time a decision on planning consent is being anticipated. The road was named after Viscountess Southwell, who used to live at France Hill House in France Hill Drive; the house is now used for adult education.

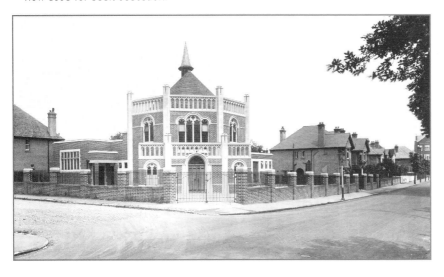

▼ **Park Street Post Office 1909** 61466
Further along Park Street we find Lower Gordon Road; the Post Office, run by a Mr H L Love, is on the corner. The premises have since been converted into a private house. Notice the decorator up his ladder taking a short break to make sure he is in the picture.

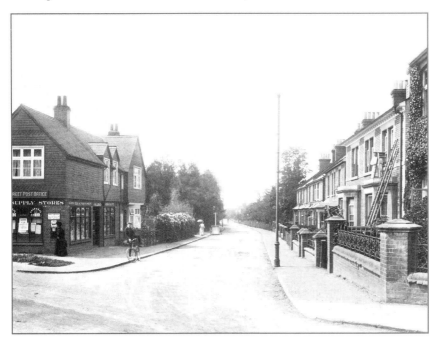

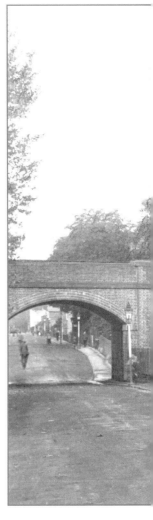

▲ **Park Street Post Office 1921** 71612
This is Park Street Railway Bridge, towards the London Road, with Middle Gordon Road on the right. Mr Love has moved to different premises, just opposite to where he had been previously. It was only the building of the Post Office in the town centre which prompted its closure, much to many people's dismay.

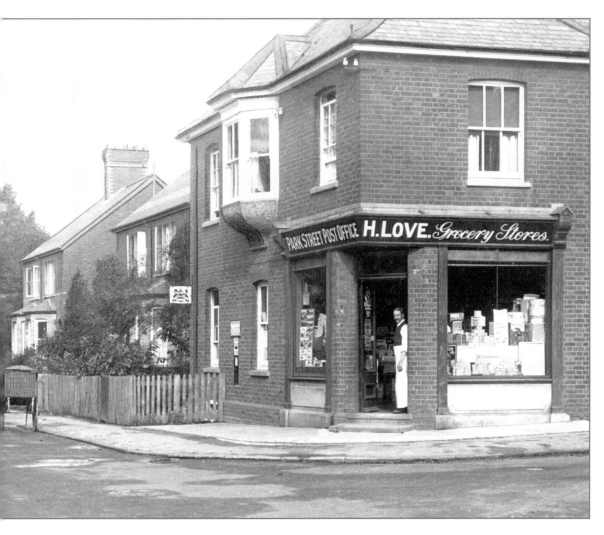

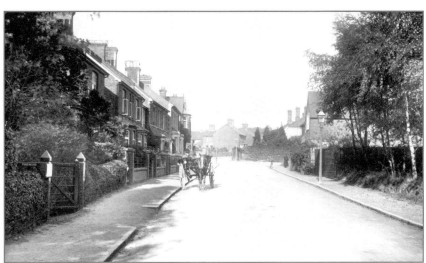

Gordon Road 1908 61034
This view looks towards Park Street, and the cottages on the left are still there. When the houses were constructed in the late 1880s, they were considered to be the first type of 'middle class' houses in Camberley.

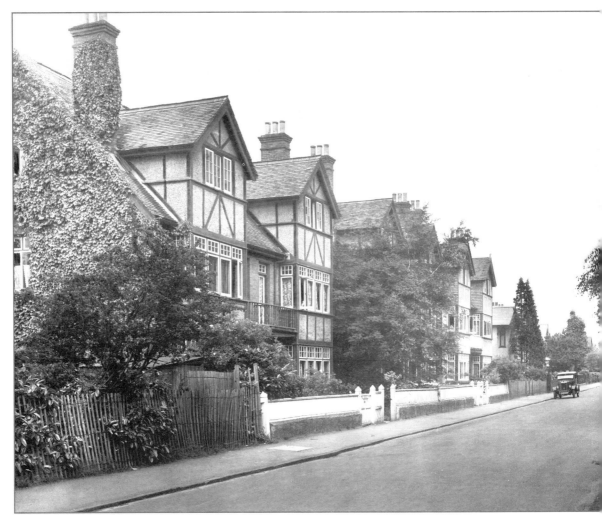

◀ **Park Road 1928** 80699
Turning right into Park Street we come to the junction with Park Road. This shows the view towards Church Hill, with 'Brackenhurst' on the right. The large number of pine trees was one of the reasons why Camberley was considered a healthy place to live in.

Gordon Road 1931 83850
We are looking in the same direction, only this time the view is taken from lower down the road, and shows the fine villas very much associated with the town. The arrival of the railway in 1878 was one of the reasons for its growth. Charles Raleigh Knight, who constructed the road in 1880, lived in Frimley Park, and it was he who was responsible for the development of Camberley.

▼ **Brackendale Road 1908** 61032
Travelling towards Church Hill we come to Brackendale Road; this is a pretty road, with many pine trees. Before the opening of the M3, it used to run right through to the Portsmouth Road. At this time the road was just being developed.

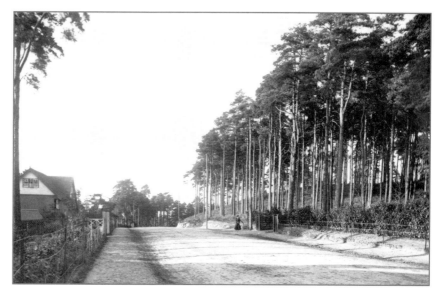

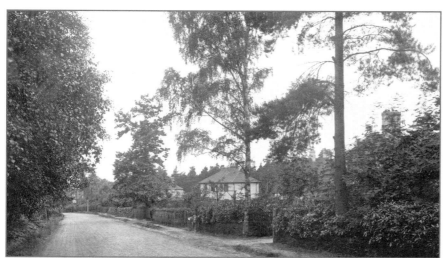

◄ **Tekels Avenue 1931** 83853
Next to Brackendale is Tekels Avenue; it was named after John Tekel, who lived at the end of this road in Tekels Castle, a house built to resemble a castle. It burnt down in 1906, and was never rebuilt. We now retrace our steps and come back into Park Road, and turn right.

▼ **St Paul's Church 1907** 57921

At the top of Church Hill we find this Swedish-style church, built in 1902 at a cost of £2678. It contains a stained glass window commemorating Sir Frederick Charles Doveton Sturdee, Bt, GCM, KCMG, CVO, who died in 1925. He won the Battle of the Falklands in 1914, and also began the setting up of a fund to preserve the 'Victory' in 1920. His grave, in St Peter's, Frimley, contains a cross made up of wood from that ship.

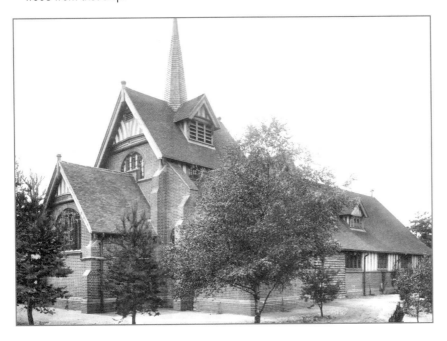

▼ **The War Memorial 1923** 73396

We travel back to the London Road, and at the entrance to the Staff College, we find the War Memorial, erected in 1922 at a cost of £433. It contains the names of 233 men from the Great War, and of 140 who lost their lives in the Second World War.

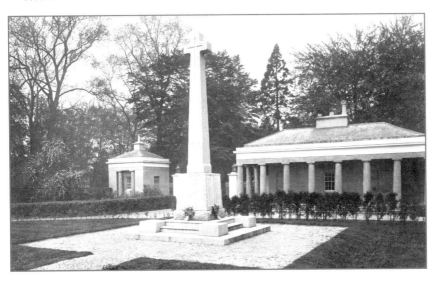

▲ **The Staff College 1901**
46829
If we turn to our right inside the gates, this building is what we would see. It was opened in 1862, and was designed by James Pennethorne, who was a pupil of Nash. It was built at a cost of £50,000, and the Duke of Cambridge laid the foundation stone in December 1859.

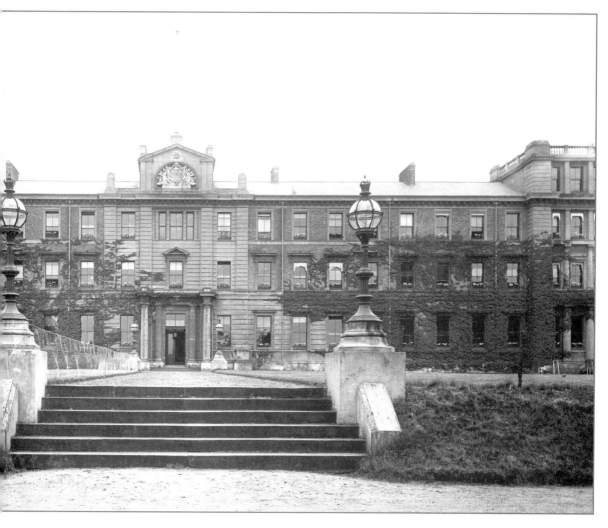

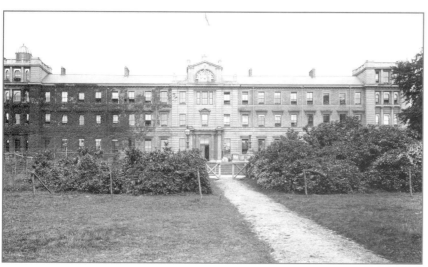

◀ **The Staff College 1907**
57917
Standing further back from the College, we can see part of the grounds in front of the building. The craftsmen were paid, according to some, the sum of 4s a day; much of the building material was transported along the Basingstoke Canal. With the exception of the Jolly Farmer, all the local hostelries were closed to them, as in their free time they were more than boisterous. Prince Albert planted the beech tree, to be seen to the right of the picture, in 1860.

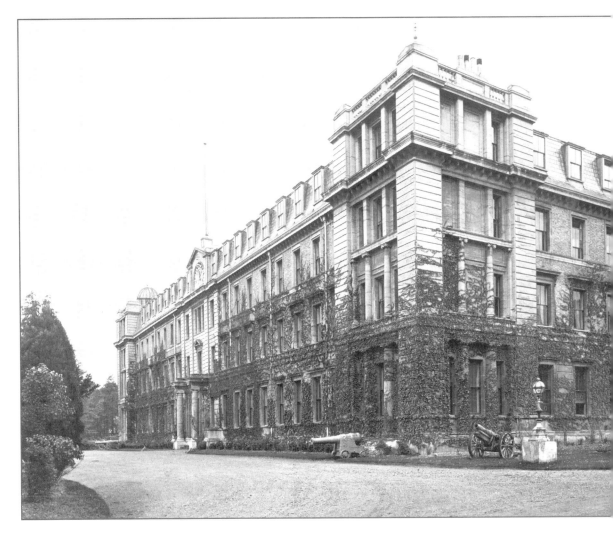

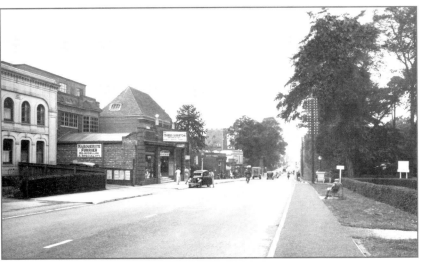

◀ **London Road 1936**
87781
Once back into the London Road, we start to go to York Town. Opposite the Staff College gates we find the Arcade Cinema, which opened in 1923; it is advertising the latest Charles Laughton film, 'Rembrandt'. Further down, where the van is passing, was the Aspen Tree public house, where my grandfather was the licensee from 1907 until it closed in 1925.

◄ The Staff College 1919

68798

If we compare this picture to the two earlier views, we can now see that a further floor, built in 1913, has been added. If we look to our left, we will gaze over the Upper Lake, and on towards the Royal Military College. The formation of a tri-services Staff College means that this splendid building is now empty.

▼ The Recreation Ground Gardens 1931

83858

The Recreation Ground opened in 1898, although these attractive gardens were not purchased until 1909. The houses in the background are those in Southwell Park Road. The tennis courts and bowling green are to the left.

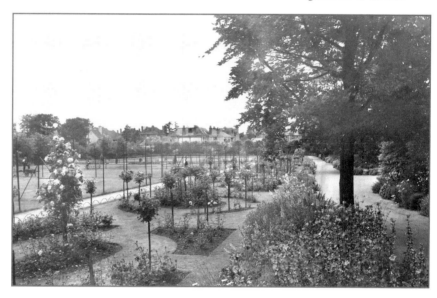

◄ London Road 1925

78123

We are now looking at the Recreation Ground, from the other side. Whites Garage is on the right; they sold sewing machines and bicycles when they first opened. The large trees have gone, and the Arena Leisure Centre now stands in their place.

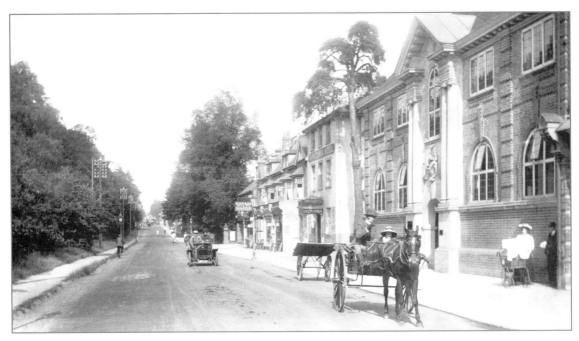

London Street 1909 61463
This shows a view towards Camberley, with the newly opened Municipal Offices on the left, built at a cost of £2,339. Next to them is the Victoria Hotel. The whole block has now been demolished, and an office block and flats is to be its replacement.

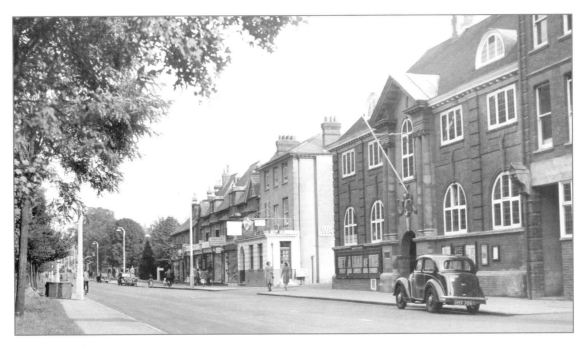

London Road c1955 C12019
Notice the advertisement outside the Municipal Offices extolling the benefits of collecting waste paper. Enclosed in the same complex were the Library and the local Museum. The Victoria Hotel did not close until 1963; it became a restaurant.

York Town and the Royal Military College, Sandhurst

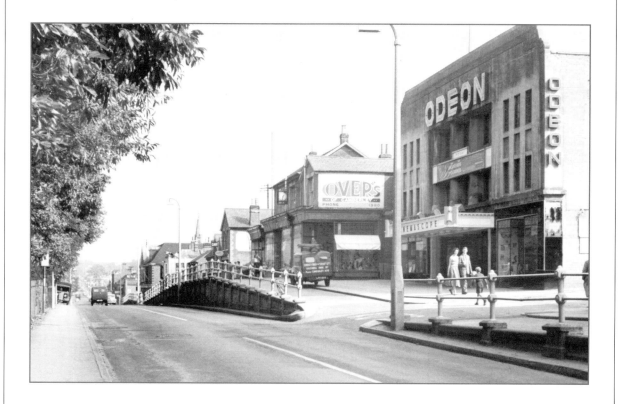

London Road c1955 C12081
Here we see the Osnaburgh Parade, with the Odeon Cinema, next
door to Overs shop. When it opened as the Regal in 1932, the first
film shown starred Jack Hulbert and Cicely Courtneidge in 'Jack's
the Boy'. The road stretches towards Camberley.

▼ **Main Road c1965** C12123

This photograph shows the London Road, with the Frimley Road on the left, and the Duke of York Hotel beyond. The trees on the right are in the Royal Military College grounds, at that time open to the public.

▼ **York Town, St Michael's Church 1901** 46818

This splendid church, designed by Mr Woodyer in Victorian Gothic style, was completed in 1850. The tower and spire, which reaches a height of 124 feet, were added later in 1891, as a memorial to Freda, daughter of the Reverend Middleton, vicar at the church for 27 years.

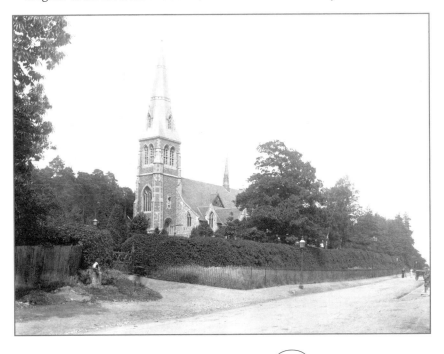

▲ **The Church of St Michael c1955**

C12022

This later view shows the improved road towards Camberley, and a familiar Aldershot and District bus. They ran everywhere in all weathers, and were 100% reliable. Notice the lack of crash helmets on the two motor cyclists.

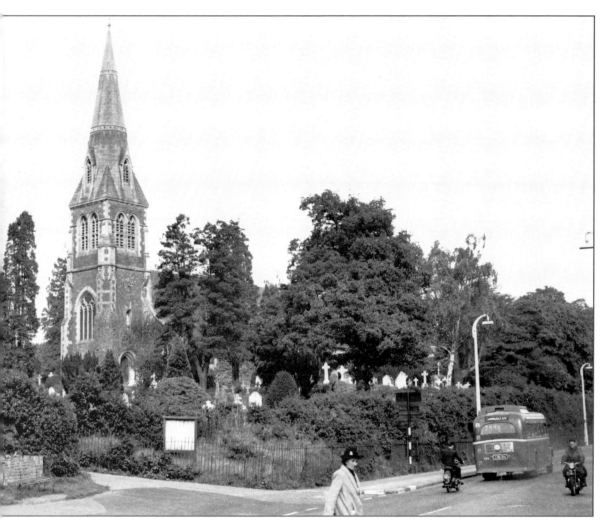

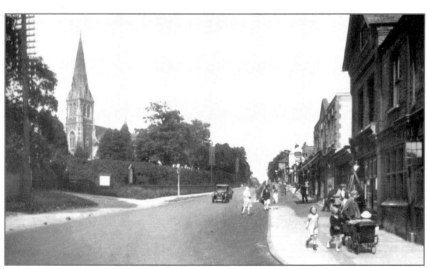

◀ **London Road 1927** 79633
We are looking from the Frimley Road up a busy Osnaburgh Parade, with Barclays Bank on the corner. The road rises quite steeply towards Camberley, and there is a lack of road markings.

▼ **London Road c1955** C12077

What a change 28 years make. Centre white lines, street lighting and traffic lights control the road junction, and there is an official bus stop outside the church. Among the more interesting graves in the churchyard are those of John Fineghan, who was an orderly to Florence Nightingale, and Sir Arthur Hammond, VC, KCB, DSO. He won his Victoria Cross in 1879 for rescuing a wounded sepoy in Afghanistan.

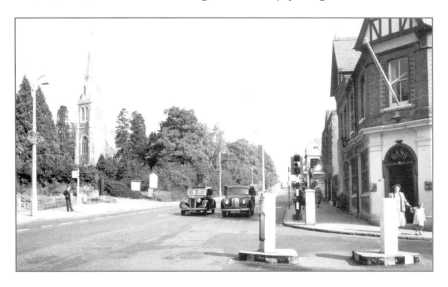

▼ **London Road 1927** 79634

An office block has replaced those quaint shops, but the Duke of York survives with its covered entrance porch, but today without the white fence. York Town contained a wide variety of shops, and there was no need to travel elsewhere for one's needs.

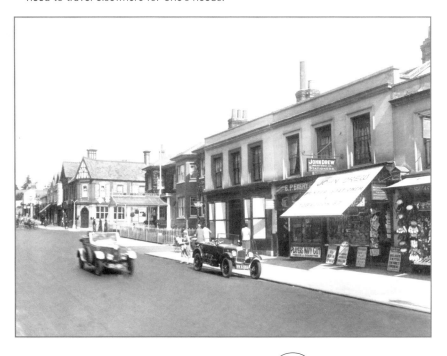

▲ **London Road 1936**
87782

Here we see an ice cream vendor with 'stop me' written on the side of his cart. This practice gave rise to that familiar 'stop me and buy one' saying, that was so popular at one time. The Duke of York is now advertising from the top of its porch, and cars can park outside. Barclays Bank no longer use the premises, and the building has become a restaurant.

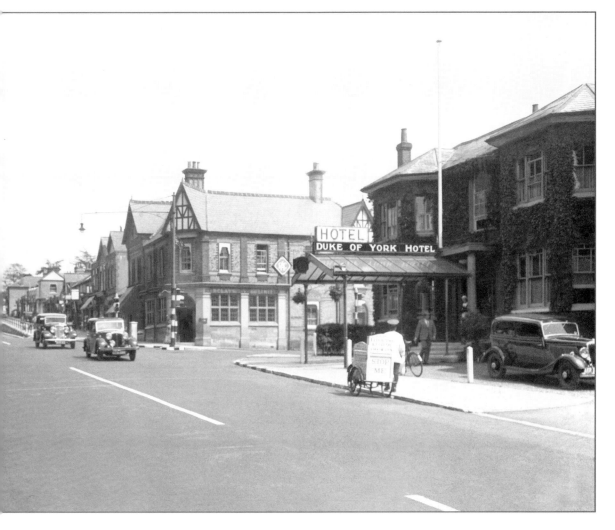

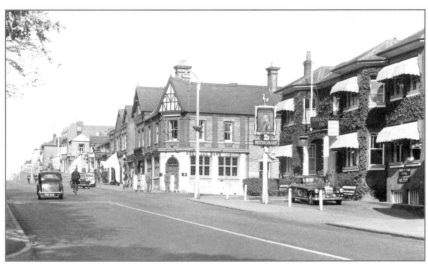

Main Road c1955 C12046
This is London Road, showing the Duke of York Hotel, now minus its covered porch, at the junction with the Frimley Road. The hotel was built in 1816 at a cost of £677 5s. by William Belsher Parfett, from Eversley. The sign outside shows HRH Frederick, Duke of York, who founded the Royal Military College in 1800.

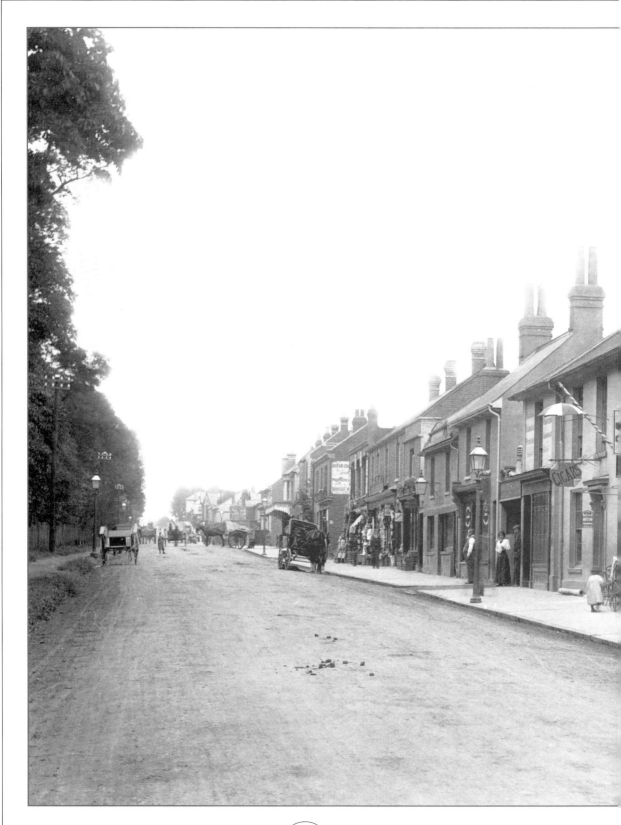

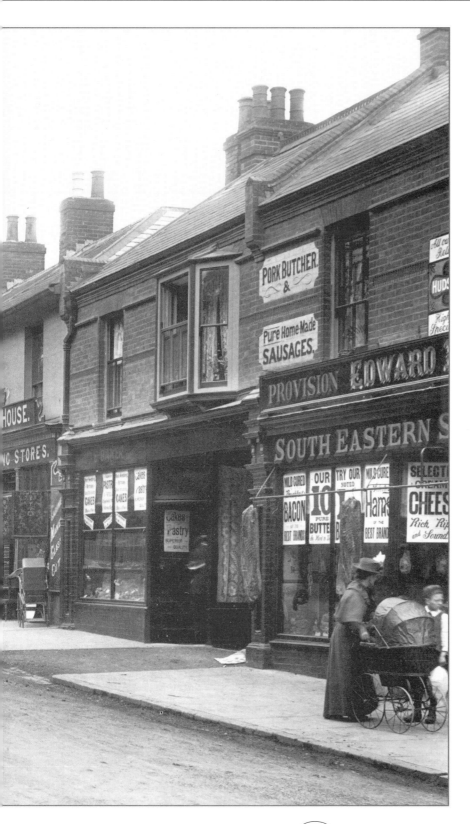

York Town, London Road 1901 46820
We are now some 500 yards further down the London Road, looking back towards the Duke of York. Many of these older cottages still exist, and on the right, just beyond the lamp post, was the Criterion Public House, which closed in 1939. We now need to return towards Camberley, and turn to the left into the Royal Military College.

▼ **The Entrance to Sandhurst Military College 1906** 56995
This lodge was built in 1831 after an outbreak of cholera in the area, so as to protect the officer cadets. Today, the gates are permanently closed, for security reasons. At one time, the cadets pulled an old cannon, just inside the gate, across the London Road after their passing out parade.

▼ **The Royal Military Academy 1901** 46822
Once inside the gate, we can see the main building across the boating lake. The land was purchased in 1801 for the grand sum of £8,000 from William Pitt, who had bought the land from one of his nieces.

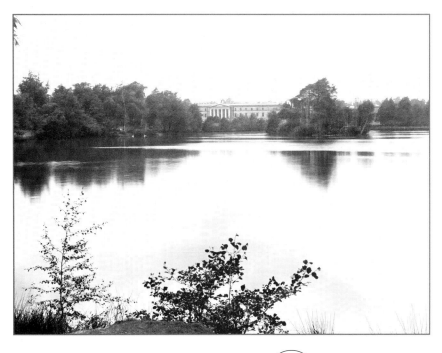

▲ **The Royal Military College 1925** 76696
We are on the other side of the lake, and we can see the building more clearly, dominated by its main entrance. It opened in 1812, and attracted many people to the area, who built houses and shops to service the College. The guiding light behind its conception was Major General Le Marchant, who had a road named after him in Frimley.

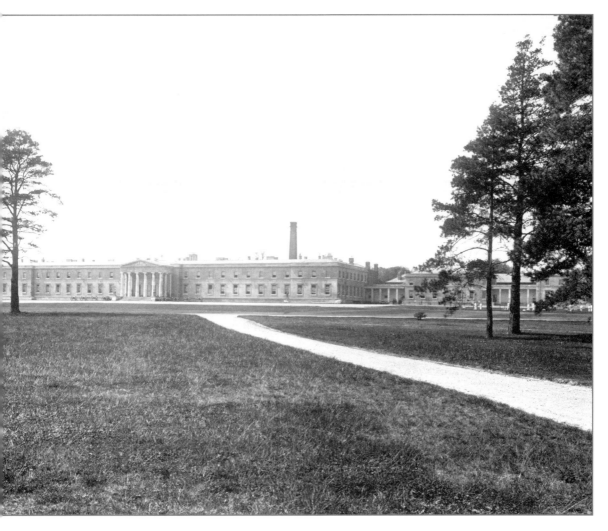

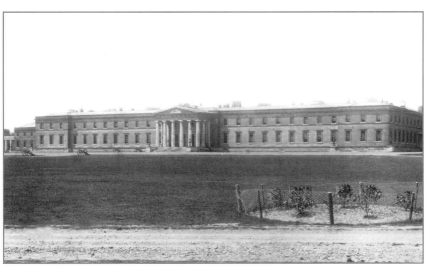

◀ **The Royal Military College 1895** 35157A
We are closer still, so that we can notice the cannons outside on the parade ground. On parade days, the adjutant rides his horse up the steps and through the main doors, followed by the cadets who have completed their passing-out parade.

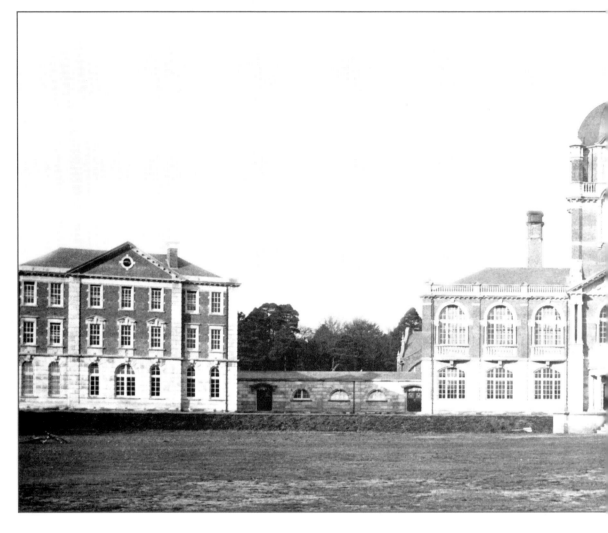

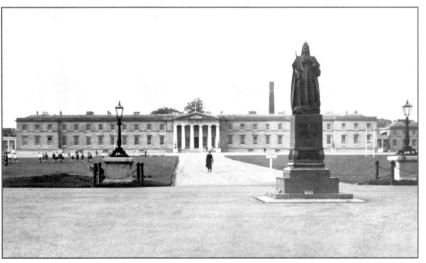

◀ **Kings Walk, The Royal Military Academy c1955** C12010
Kings Walk leads us back to the exit, past the Victoria Statue unveiled in 1904 by the Duke of Connaught, after being erected by cadets and others who had connections with the College. Since the acadamy opened, very little has changed.

The Royal Military College 1911 64049
Walking to the right, we come to New College, which was completed in 1911; on its opening the size of the Academy was doubled. The final cost of the Academy was £350,000, which was nearly double the estimate.

Frimley Road 1931 83849
We now start to go down the Frimley Road, and this is the junction with Edward Avenue. Before any building on the right, it was called Domans Meadow, and was the site of Bronco Bill's Circus in 1917. Camberley Football Club used to play there as well.

Frimley Road 1931 83852
We are nearer to Frimley, and we are now looking towards the London Road. The houses have survived, but unfortunately the trees have not. The absence of any traffic would be a welcome sight today.

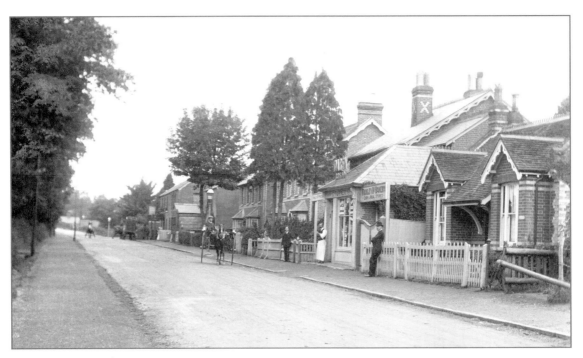

Frimley Road 1906 57182A
We cross the railway bridge, and look back from where we have come from. On the right is Mr Turner's grocery shop, with the Standard public house in the distance. Many of these old cottages remain.

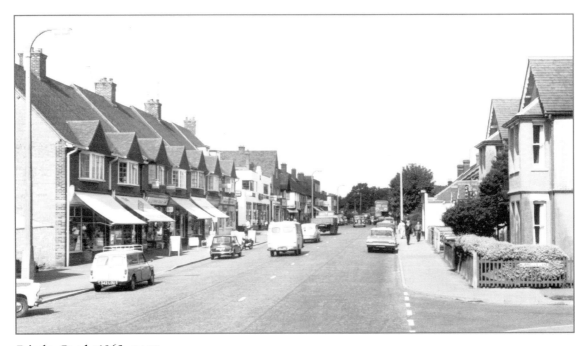

Frimley Road c1965 C12126
This is the same view as in photograph No 57182A, and we can see that Mr Turner's shop still survives: it is the one with the whitewashed side, on the right by the first lamp-post. It is now used for a different business. The road on the left is Krooner Road.

South and East of Camberley

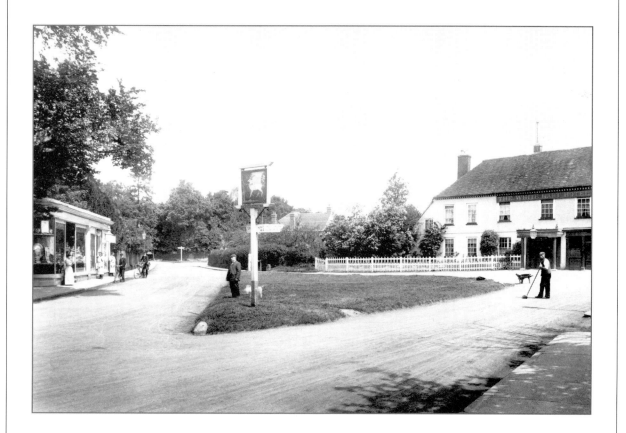

Frimley, The White Hart 1906 55635
At the end of the Frimley Road, we arrive in Frimley, and find the
road dominated by this ancient hostelry, supposedly going as far
back as the 16th century. The green in front replaced a small
pond, which horses used for refreshment whilst their riders were
inside the premises.

▼ **Frimley, The Bridge 1906** 55637
At the other end of Frimley High Street, we cross the River Blackwater, which is the boundary between Surrey and Hampshire. Near to this bridge in 1860, a fight took place that has gone down in the history of boxing as one of the important fights of the century. It was a bare-knuckle fight between Tom Sayer, from England, and John Heenan, the American. After 42 rounds, it was declared a draw.

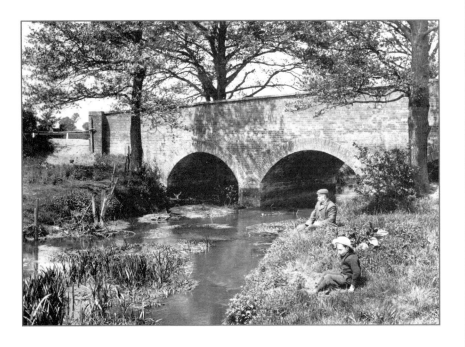

▼ **Frimley, High Street 1901** 46835
The White Hart has dominated the High Street, allegedly since the middle of the 16th century. To the right, just out of the picture, was the site of the old Smithy, now occupied by Goddard and Grants, a stockist of Francis Frith's prints.

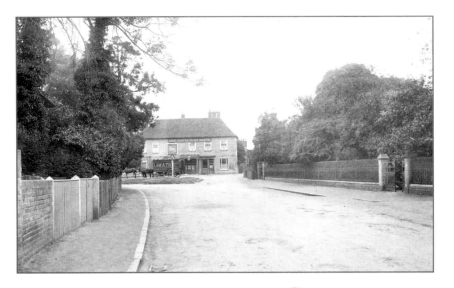

▲ **Frimley, The Green 1906** 54905
We go along the Frimley Green Road, and arrive at Frimley Green, with Wharf Road to the left of the picture. The shop and the house next door have been replaced by a modern parade of shops.

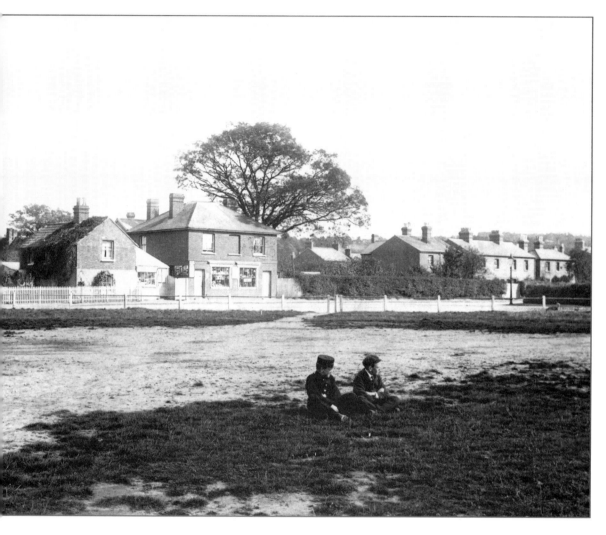

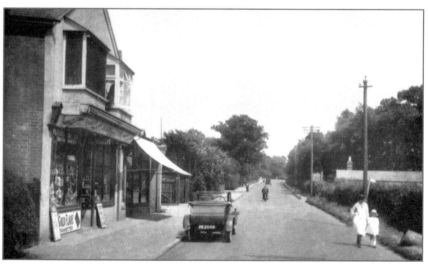

**Frimley, Wharf Road
1927** 79627
The shop of J Singleton,
where you could shop and
also acquire a haircut, is no
longer a general-purpose
shop. The road leads to
Deepcut, at that time the
home to a great number
of soldiers.

▼ **Frimley, An Old Cottage 1906** 54907
This cottage was believed to have been in the Guildford Road, and
not demolished until the early part of the 20th century. It was typical
of the many older buildings in the area in this largely rural village,
which contains some 15th- and 16th-century farmhouses.

▼ **Frimley Green, Guildford Road 1927** 79626
This view is from the railway bridge, with Deek's Garage on the right.
Behind, just out of shot on the left would be The Bridge House public
house; it closed in 1931, although the buildings are now used as
private dwellings.

▲ **Frimley Green, The
Canal and the New
Boathouse 1909** 61829
The Basingstoke Canal
was opened in 1794, and
stretches for a length of
37 miles from the River
Wey to Basingstoke.
Notice how the canal
crosses in an aqueduct
over the main railway
line. This part of the canal
was used for the
Aldershot Regatta in the
same year as this
photograph, 1909.

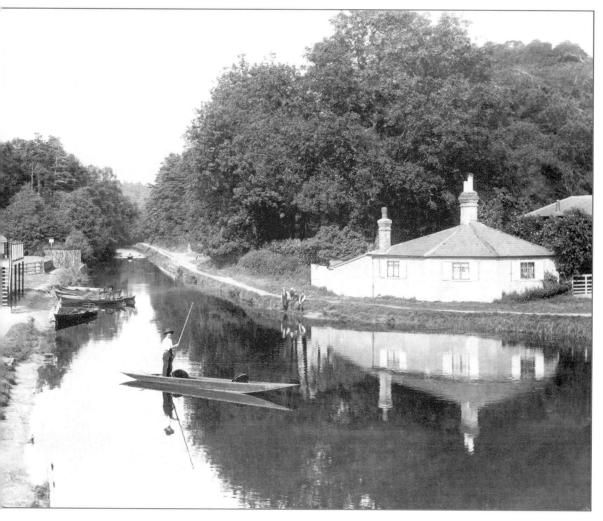

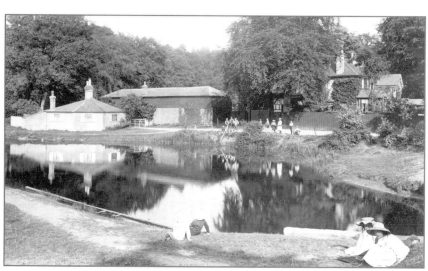

Frimley, On the Canal 1909 61830
This view, this time from the boathouse side of the canal, shows Frimhurst Lodge, with Frimhurst behind the trees in the background. In the late 1800s it was the home of Dame Ethel Smyth, the concert pianist and composer.

▼ Bisley, The Village c1955 B109002

We leave Frimley and travel to Bisley, on the road to Guildford. The Hen and Chickens public house is to the right of the picture, with the road going towards Guildford. This quaint village came under the jurisdiction of Woking up to recent times.

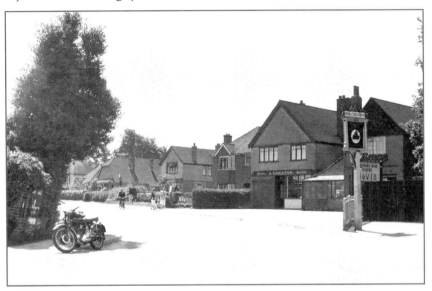

▼ Bisley, Port Lane 1914 67074

Continuing along the road, we come to the turn-off which leads to the NRA on the left, now called Queens Road. The main road leads back to Bagshot. The shop and cottages have survived the ravages of modernisation.

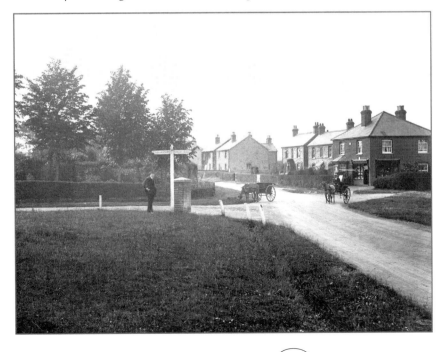

▲ Bisley, The NRA Offices 1909 61323

If we follow the signs, we come to the National Rifle Association Offices and Ranges, known the world over. They opened in 1890, and a station was built at the end of a spur line from Brookwood. The line was removed in 1954.

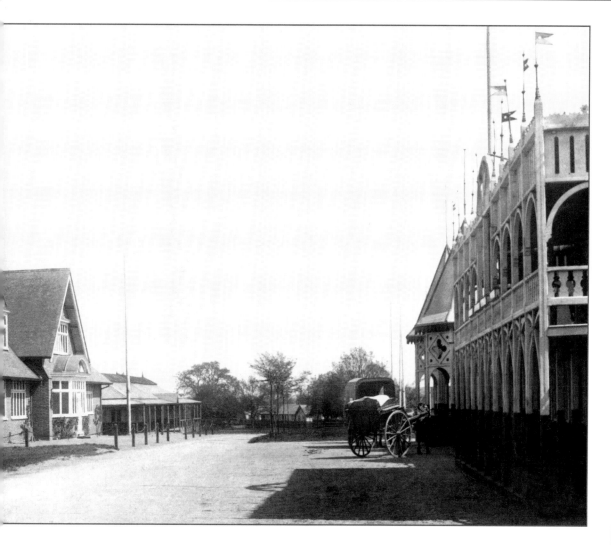

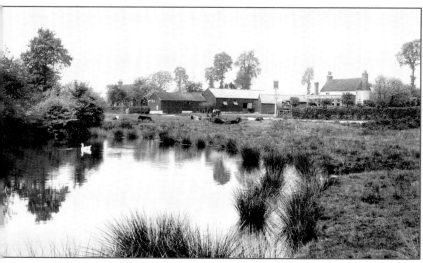

◀ Bisley, The Fox Inn 1911
63145
We go further towards Guildford, and come to the Fox Inn, at that time supplied by Simonds from Reading. This tranquil scene has changed somewhat with the erection of houses and a garage next door to the inn.

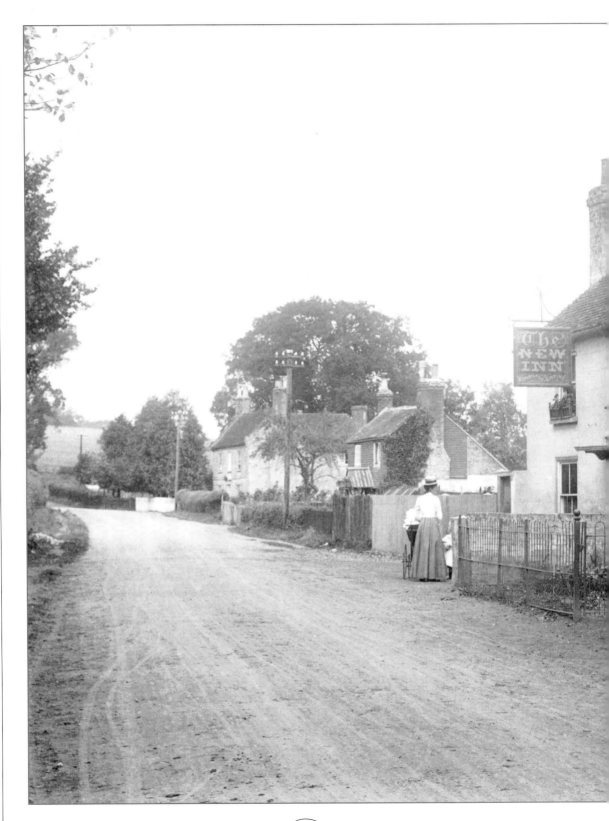

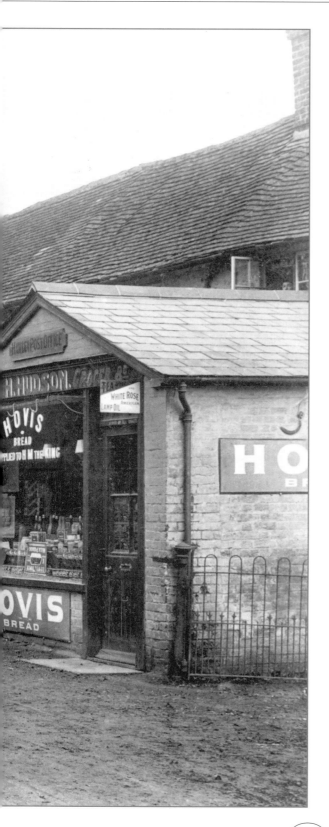

North and West of Camberley

Hawley, The Village 1906 57004
Returning once again to Frimley, we leave in the direction of Hawley, and cross the county border into Hampshire. Hawley Lane still contains the New Inn, which is now much enlarged. The Post Office, with the Hovis adverts, no longer serves the local population.

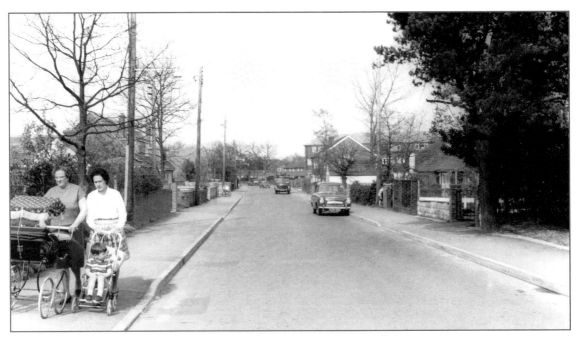

Hawley, Sandy Lane c1960 H50014
Just before the New Inn we find Sandy Lane on our left. There are not many changes today, but it is now far more busy with increased building in Hawley and Cove, with the result that many of the smaller villages have all but lost their separate identity.

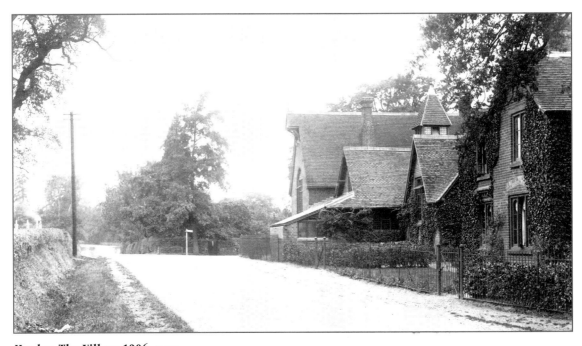

Hawley, The Village 1906 57005
We go back into Hawley Lane and arrive at Hawley School, with Vicarage Lane to the right, just past the school buildings. Where the road ends, just out of view, is Hawley Church. Both of my children went to this school, which retains its village atmosphere.

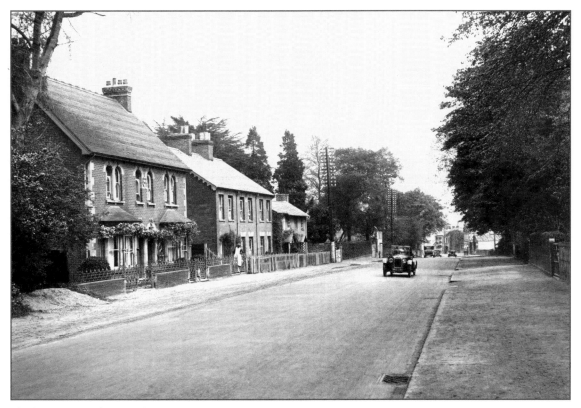

Blackwater, London Road 1928 80700

**Blackwater
London Road 1928**
At the bottom of Vicarage Lane we come to London Road, Blackwater. This is the scene looking towards Camberley. The old Barley Mow public house was based in the last building on the left. We now take the road towards Yateley.

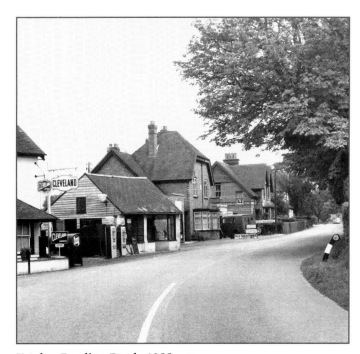

**Yateley
Reading Road c1955**
This was the main road through the village, before the advent of by-passes; we are looking back in the direction of Blackwater. This was the A327.

Yateley, Reading Road c1955 Y6015

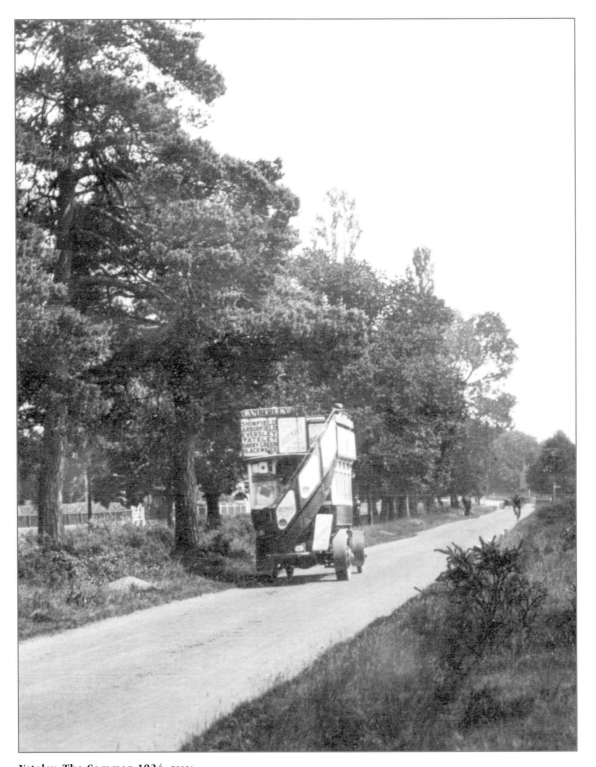

Yateley, The Common 1924 75556
A bus with solid rubber tyres heads towards its Camberley destination on a road that was not made up. The Common was typical of the scenery around this area, and it was one of the reasons for its popularity.

Yateley, The Village c1955 Y6013
Compared to photograph 57007, we can see that Tice and Son are still in business, but the old steam bakery, which was next door, has been demolished. The green is now fenced.

Yateley, The Post Office c1950 Y6004
The Post Office was next to the Dog and Partridge, and compared to the previous picture we can see that the telephone box was white, before they became red in colour. The main road towards Reading is to the right.

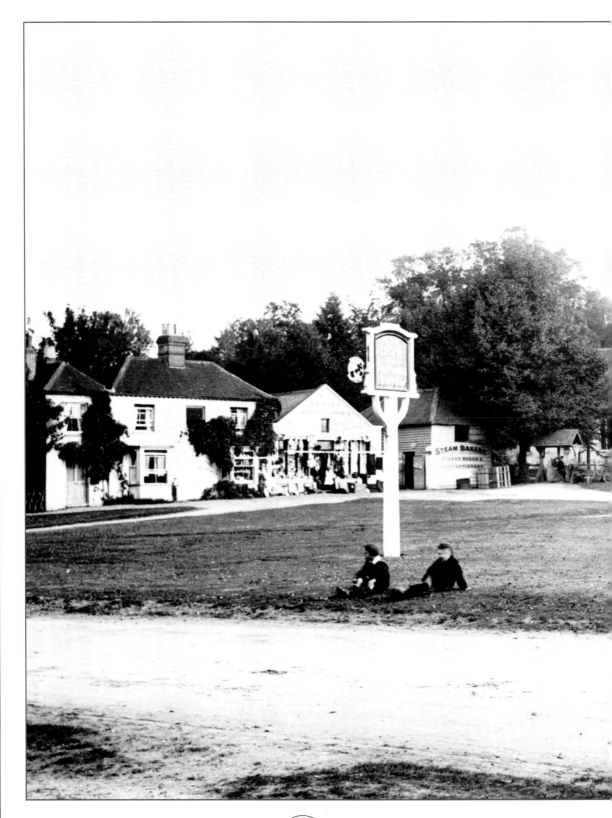

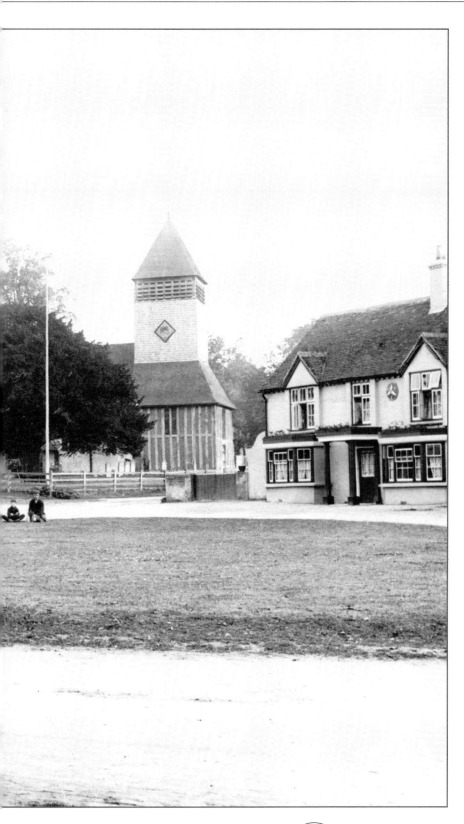

Yateley, The Village 1906 57007
The church dominates this view. Today we see a new church on the same site; a fire destroyed the old building. The Dog and Partridge still serves its customers from the same location.

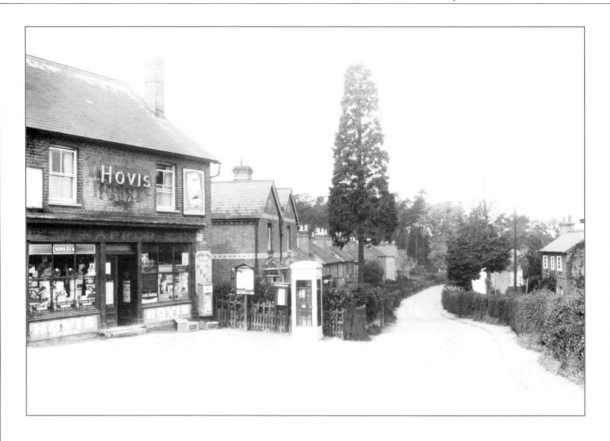

Sandhurst
Little Sandhurst 1939 88875
From Yateley, we take the road to Sandhurst, and on to Little
Sandhurst; here we see Napper's store, with its fine Hovis
advertisements. Today, it is still a general store
in Little Sandhurst High Street.

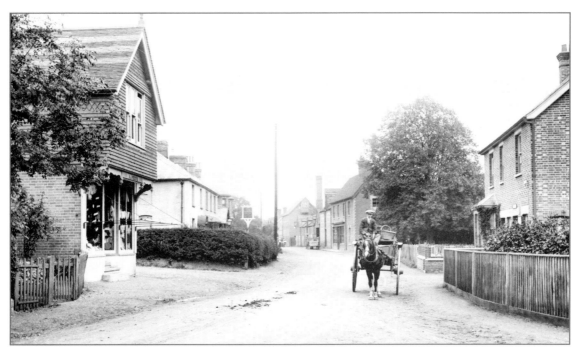

Sandhurst, The Village 1906 56999
On our way back to Camberley we arrive at the Dukes Head public house. Notice the telegraph poles supplying the new telephone system to those who could afford it.

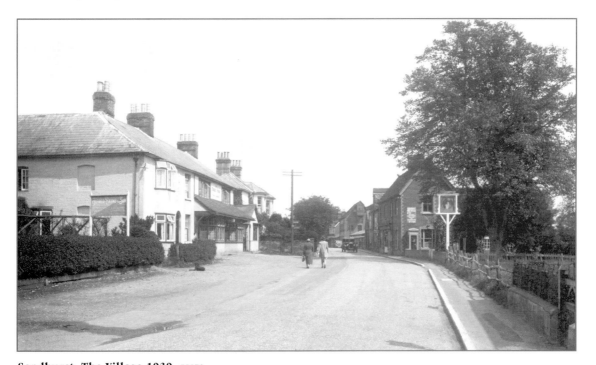

Sandhurst, The Village 1939 88873
Cars have replaced horses, and just out of shot, on the right, would be the Rose and Crown public house. Today, the Post Office, the first building on the right, is a bathroom showroom.

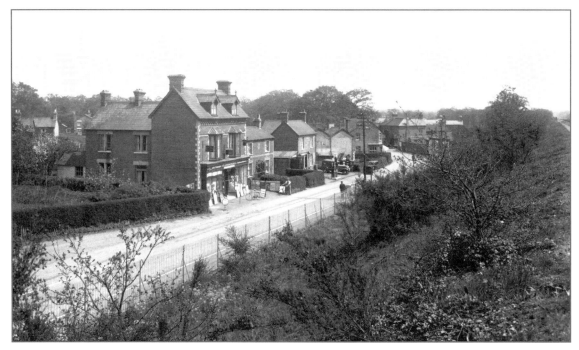

Sandhurst, The Village 1939 88867
The photographer was probably standing on the platform of Sandhurst Halt when he took this picture. The Petrol Garage is still trading today. The road stretches towards College Town and Camberley.

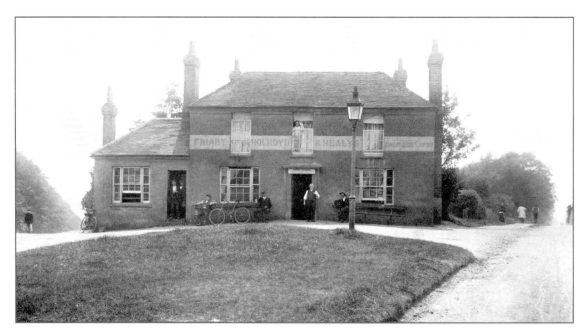

Bagshot, The Jolly Farmer Inn 1906 55835
Returning to Camberley, we carry on in the direction of London, and arrive at this inn at the junction of the London Road with the Portsmouth Road to the left. The inn derived its name from William Davis, a highwayman; he lived at a nearby farm, and paid his debts in gold. He ended his days at the end of a rope in London in 1690, and his body was hung from a gibbet in front of the inn.

Bagshot, Jolly Farmer Hill 1906 55836
This is the London Road, looking from the Jolly Farmer towards Bagshot, with Jenkins Hill in the background. There is no tarmac road or street lighting at this date, but telephone lines were beginning to be installed.

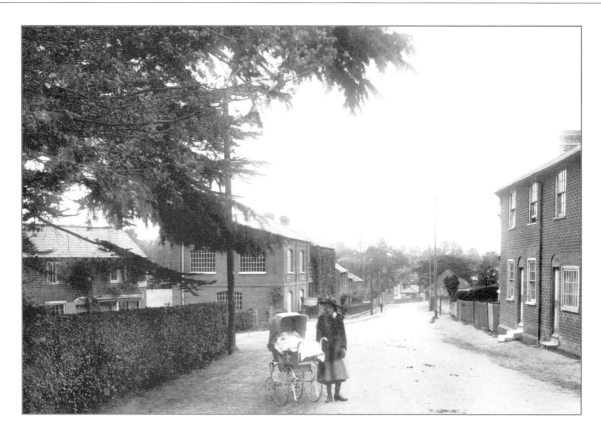

Bagshot
Portsmouth Road 1903 50985
We are closer to Bagshot village, and
we see Higgs Lane to the left, and the
High Street in the distance. The road is
now called the London Road, and
most of the cottages in this picture are
still there today.

Bagshot
Village Children 1903 50991
As we turn down Higgs Lane, this is what we would see looking back towards the main road. The large house was called Yaverlands; sad to say, it no longer exists, having been pulled down in the 1970s.

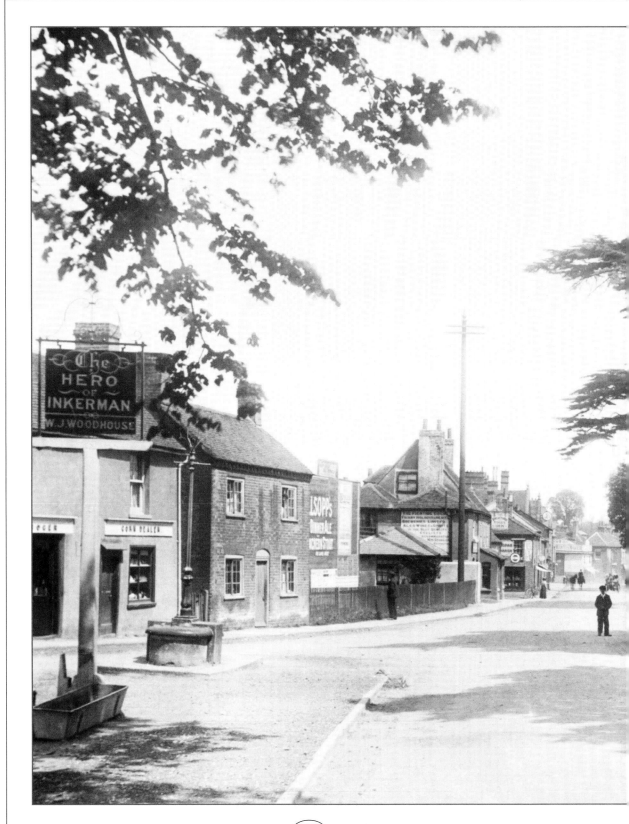

**Bagshot, High Street
1903** 50983
The Fighting Cocks Inn
can be seen on our left,
but the Hero of
Inkerman was
demolished to make
way for the new by-
pass, and was re-built
further to the left. After
a fire new premises
were built on the site,
called The Windle
Brook.

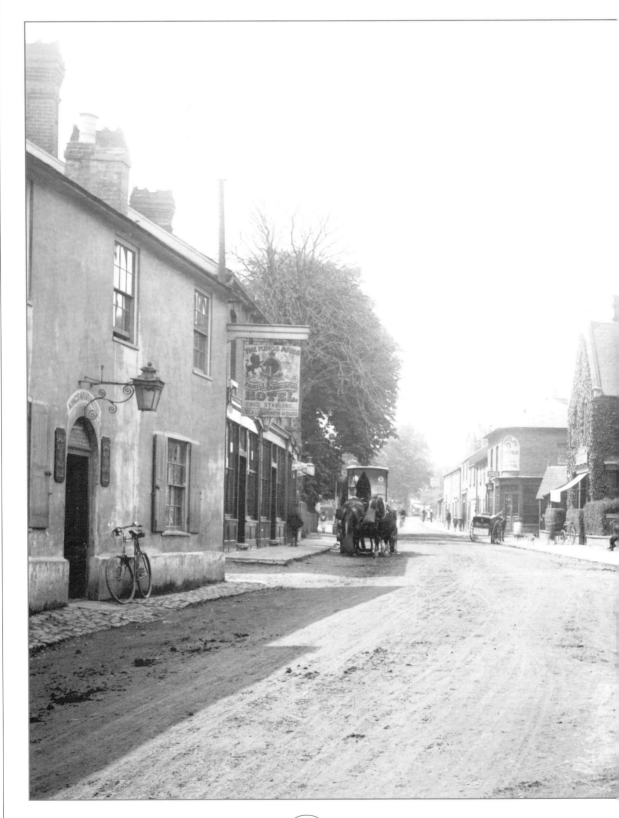

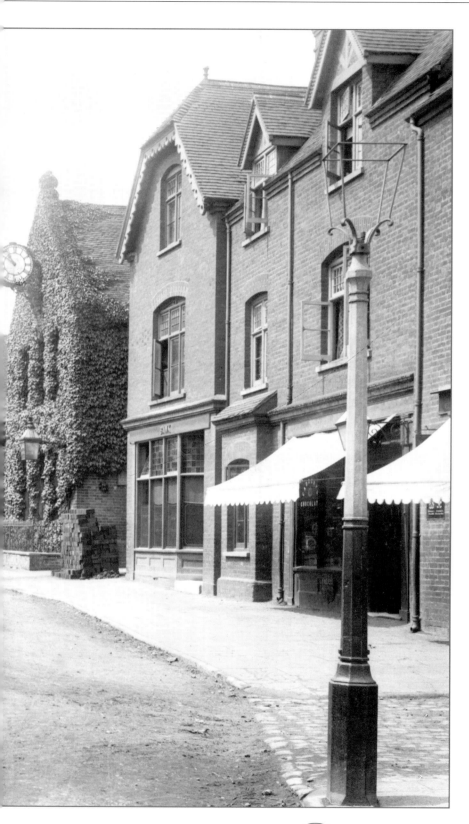

**Bagshot, High Street
1901** 46845
We now see the view
towards Camberley,
with the old Kings Arms
Hotel, which was
replaced and re-built
further back, where it
stands today. The
building with the clock
became a cinema, and
although the cinema
has ceased to trade, the
clock remains.

▼ **Bagshot, The River 1903** 50992
Turning to our left, this is what we would have seen in 1903, with the
Windle Brook flowing towards the viaduct. Just to the rear is the
Three Mariners public house, and in front is Wardle Close.

▼ **Bagshot, The Viaduct 1901** 46850
The railway came through Bagshot in 1878, which necessitated this
viaduct being constructed. The first house on the left is Peel House,
which was built in 1851 as Bagshot Police Station, one of only four in
the whole of Surrey at that time.

▲ **Bagshot, The By-Pass
Road 1925** 78023
The newly-constructed
road stretches in the
direction of Camberley,
with the Station Lodge to
Bagshot Park on the right.
It was once the home of
the Duke of Connaught,
before being used by the
Royal Army Chaplains
Department. In more
recent times it has
become the home to
Prince Edward and the
Countess of Wessex.

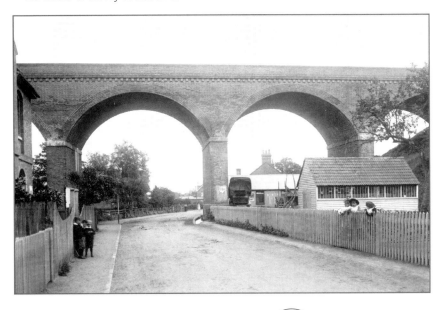

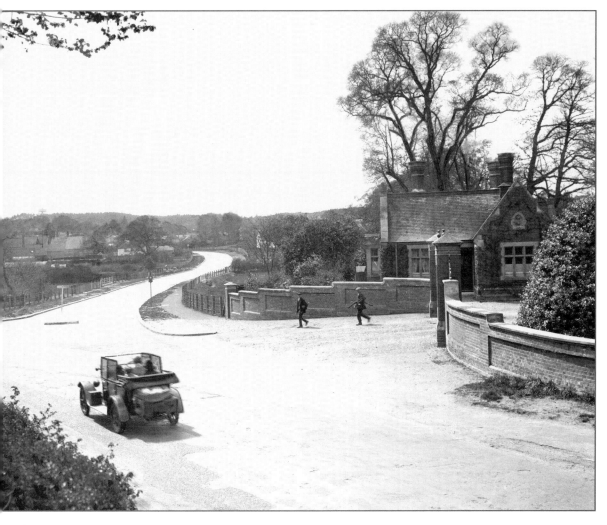

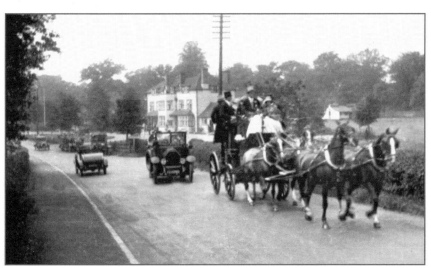

◄ **Bagshot, The Cricketers Inn 1927** 79604
We are in London Road, with a mixture of transport passing, right by The Cricketer's Inn, which has now had some extensions added. It was an extremely popular inn, especially during Royal Ascot Week, when it would be full.

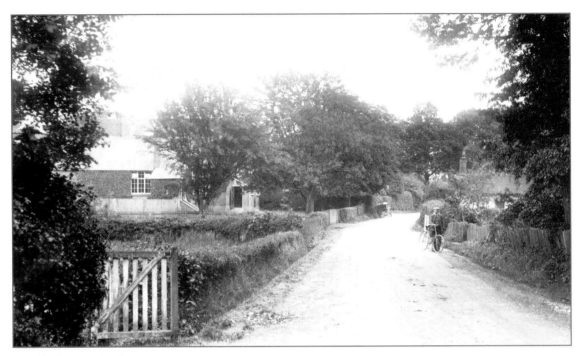

Windlesham, School Lane 1909 61453
Turning right into School Lane, we find the old Village School on the left, which opened in about 1814, and is now known as Windlesham First School. The lane leads to Windlesham village.

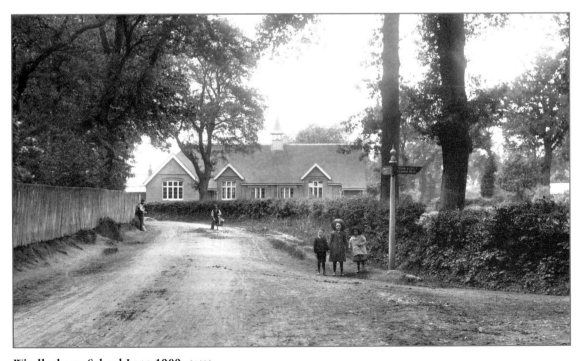

Windlesham, School Lane 1909 61456
This is now called Kennel Lane, and the building is that of the Windlesham Institute. The road to the right is Hatton Hill Road, and leads to the London Road.

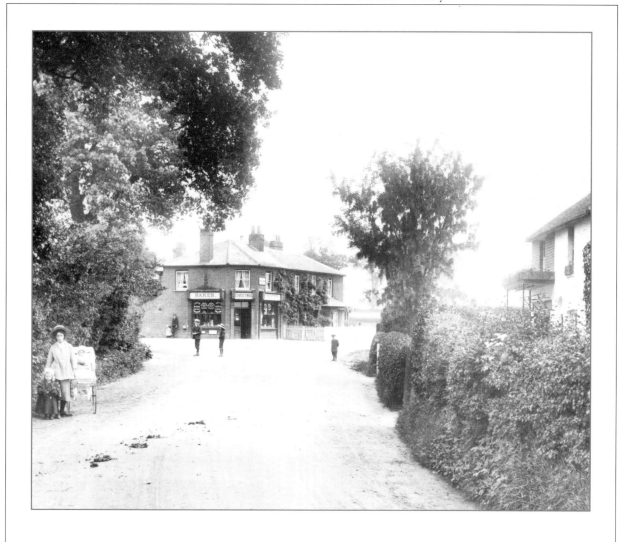

Windlesham
The Village 1909 61451
The bakery of Mr Christmas stands at the junction of Kennel
Lane and Church Road, to the right. The shop on the right is
that of Boyce the fishmongers. If we take the road to the left
we come to our last picture.

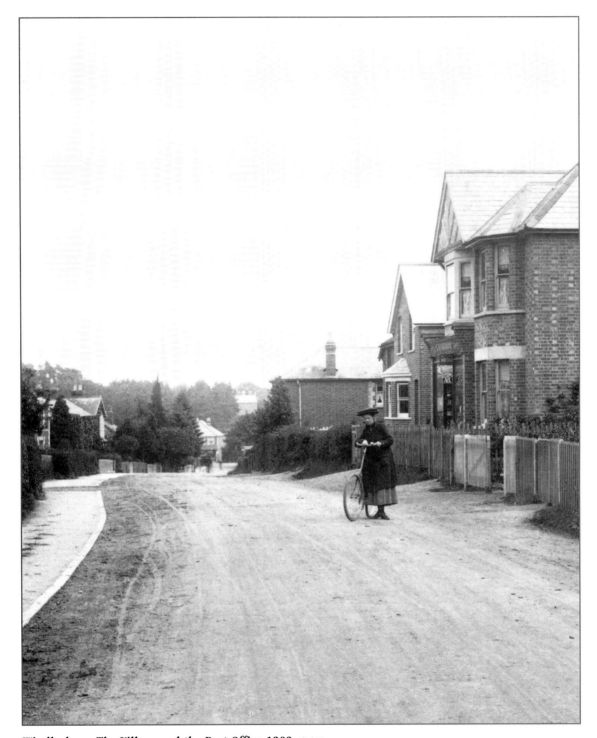

Windlesham, The Village and the Post Office 1909 61452
This view was taken in the middle of the village, and is looking down Updown Hill. The shop just behind the lady, on the right, was that of S Workman, who sold fancy goods; it is now an estate agents. We have now completed our look around Camberley, and by taking the road back to the London Road, we can return to Camberley itself, and our starting point.

Index

Frith Book Co Titles

www.frithbook.co.uk

The Frith Book Company publishes over 100 new titles each year. A selection of those currently available are listed below. For latest catalogue please contact Frith Book Co.

Town Books 96pp, 100 photos. County and Themed Books 128pp, 150 photos (unless specified). All titles hardback laminated case and jacket except those indicated pb (paperback)

Around Bakewell	1-85937-113-2	£12.99	Around Great Yarmouth	1-85937-085-3	£12.99
Around Barnstaple	1-85937-084-5	£12.99	Around Guildford	1-85937-117-5	£12.99
Around Bath	1-85937-097-7	£12.99	Hampshire	1-85937-064-0	£14.99
Berkshire (pb)	1-85937-191-4	£9.99	Around Harrogate	1-85937-112-4	£12.99
Around Blackpool	1-85937-049-7	£12.99	Around Horsham	1-85937-127-2	£12.99
Around Bognor Regis	1-85937-055-1	£12.99	Around Ipswich	1-85937-133-7	£12.99
Around Bournemouth	1-85937-067-5	£12.99	Ireland (pb)	1-85937-181-7	£9.99
Brighton (pb)	1-85937-192-2	£8.99	Isle of Man	1-85937-065-9	£14.99
British Life A Century Ago	1-85937-103-5	£17.99	Isle of Wight	1-85937-114-0	£14.99
Buckinghamshire (pb)	1-85937-200-7	£9.99	Kent (pb)	1-85937-189-2	£9.99
Around Cambridge	1-85937-092-6	£12.99	Around Leicester	1-85937-073-x	£12.99
Cambridgeshire	1-85937-086-1	£14.99	Leicestershire (pb)	1-85937-185-x	£9.99
Canals and Waterways	1-85937-129-9	£17.99	Around Lincoln	1-85937-111-6	£12.99
Cheshire	1-85937-045-4	£14.99	Lincolnshire	1-85937-135-3	£14.99
Around Chester	1-85937-090-x	£12.99	London (pb)	1-85937-183-3	£9.99
Around Chichester	1-85937-089-6	£12.99	Around Maidstone	1-85937-056-x	£12.99
Churches of Berkshire	1-85937-170-1	£17.99	New Forest	1-85937-128-0	£14.99
Churches of Dorset	1-85937-172-8	£17.99	Around Newark	1-85937-105-1	£12.99
Colchester (pb)	1-85937-188-4	£8.99	Around Newquay	1-85937-140-x	£12.99
Cornwall	1-85937-054-3	£14.99	North Devon Coast	1-85937-146-9	£14.99
Cumbria	1-85937-101-9	£14.99	Northumberland and Tyne & Wear		
Dartmoor	1-85937-145-0	£14.99		1-85937-072-1	£14.99
Around Derby	1-85937-046-2	£12.99	Norwich (pb)	1-85937-194-9	£8.99
Derbyshire (pb)	1-85937-196-5	£9.99	Around Nottingham	1-85937-060-8	£12.99
Devon	1-85937-052-7	£14.99	Nottinghamshire (pb)	1-85937-187-6	£9.99
Dorset	1-85937-075-6	£14.99	Around Oxford	1-85937-096-9	£12.99
Dorset Coast	1-85937-062-4	£14.99	Oxfordshire	1-85937-076-4	£14.99
Down the Severn	1-85937-118-3	£14.99	Peak District	1-85937-100-0	£14.99
Down the Thames	1-85937-121-3	£14.99	Around Penzance	1-85937-069-1	£12.99
Around Dublin	1-85937-058-6	£12.99	Around Plymouth	1-85937-119-1	£12.99
East Sussex	1-85937-130-2	£14.99	Around St Ives	1-85937-068-3	£12.99
Around Eastbourne	1-85937-061-6	£12.99	Around Scarborough	1-85937-104-3	£12.99
Edinburgh (pb)	1-85937-193-0	£8.99	Scotland (pb)	1-85937-182-5	£9.99
English Castles	1-85937-078-0	£14.99	Scottish Castles	1-85937-077-2	£14.99
Essex	1-85937-082-9	£14.99	Around Sevenoaks and Tonbridge		
Around Exeter	1-85937-126-4	£12.99		1-85937-057-8	£12.99
Exmoor	1-85937-132-9	£14.99	Around Southampton	1-85937-088-8	£12.99
Around Falmouth	1-85937-066-7	£12.99	Around Southport	1-85937-106-x	£12.99

Available from your local bookshop or from the publisher

Frith Book Co Titles (continued)

Around Shrewsbury	1-85937-110-8	£12.99
Shropshire	1-85937-083-7	£14.99
South Devon Coast	1-85937-107-8	£14.99
South Devon Living Memories		
	1-85937-168-x	£14.99
Staffordshire (96pp)	1-85937-047-0	£12.99
Stone Circles & Ancient Monuments		
	1-85937-143-4	£17.99
Around Stratford upon Avon		
	1-85937-098-5	£12.99
Sussex (pb)	1-85937-184-1	£9.99

Around Torbay	1-85937-063-2	£12.99
Around Truro	1-85937-147-7	£12.99
Victorian & Edwardian Kent		
	1-85937-149-3	£14.99
Victorian & Edwardian Yorkshire		
	1-85937-154-x	£14.99
Warwickshire (pb)	1-85937-203-1	£9.99
Welsh Castles	1-85937-120-5	£14.99
West Midlands	1-85937-109-4	£14.99
West Sussex	1-85937-148-5	£14.99
Wiltshire	1-85937-053-5	£14.99
Around Winchester	1-85937-139-6	£12.99

Frith Book Co titles available Autumn 2000

Croydon Living Memories (pb)			
	1-85937-162-0	£9.99	Aug
Glasgow (pb)	1-85937-190-6	£9.99	Aug
Hertfordshire (pb)	1-85937-247-3	£9.99	Aug
North London	1-85937-206-6	£14.99	Aug
Victorian & Edwardian Maritime Album			
	1-85937-144-2	£17.99	Aug
Victorian Seaside	1-85937-159-0	£17.99	Aug
Cornish Coast	1-85937-163-9	£14.99	Sep
County Durham	1-85937-123-x	£14.99	Sep
Dorset Living Memories	1-85937-210-4	£14.99	Sep
Herefordshire	1-85937-174-4	£14.99	Sep
Kent Living Memories	1-85937-125-6	£14.99	Sep
Leeds (pb)	1-85937-202-3	£9.99	Sep
Ludlow (pb)	1-85937-176-0	£9.99	Sep
Norfolk (pb)	1-85937-195-7	£9.99	Sep
Somerset	1-85937-153-1	£14.99	Sep
Tees Valley & Cleveland	1-85937-211-2	£14.99	Sep
Thanet (pb)	1-85937-116-7	£9.99	Sep
Tiverton (pb)	1-85937-178-7	£9.99	Sep
Victorian and Edwardian Sussex			
	1-85937-157-4	£14.99	Sep

Weymouth (pb)	1-85937-209-0	£9.99	Sep
Worcestershire	1-85937-152-3	£14.99	Sep
Yorkshire Living Memories	1-85937-166-3	£14.99	Sep
British Life A Century Ago (pb)			
	1-85937-213-9	£9.99	Oct
Camberley (pb)	1-85937-222-8	£9.99	Oct
Cardiff (pb)	1-85937-093-4	£9.99	Oct
Carmarthenshire	1-85937-216-3	£14.99	Oct
Cornwall (pb)	1-85937-229-5	£9.99	Oct
English Country Houses	1-85937-161-2	£17.99	Oct
Gloucestershire	1-85937-102-7	£14.99	Oct
Humberside	1-85937-215-5	£14.99	Oct
Manchester (pb)	1-85937-198-1	£9.99	Oct
Middlesex	1-85937-158-2	£14.99	Oct
Norfolk Living Memories	1-85937-217-1	£14.99	Oct
Preston (pb)	1-85937-212-0	£9.99	Oct
South Hams	1-85937-220-1	£14.99	Oct
Suffolk	1-85937-221-x	£9.99	Oct
Swansea (pb)	1-85937-167-1	£9.99	Oct
West Yorkshire (pb)	1-85937-201-5	£9.99	Oct

See Frith books on the internet www.frithbook.co.uk

FRITH PRODUCTS & SERVICES

Francis Frith would doubtless be pleased to know that the pioneering publishing venture he started in 1860 still continues today. A hundred and forty years later, The Francis Frith Collection continues in the same innovative tradition and is now one of the foremost publishers of vintage photographs in the world. Some of the current activities include:

Interior Decoration

Today Frith's photographs can be seen framed and as giant wall murals in thousands of pubs, restaurants, hotels, banks, retail stores and other public buildings throughout the country. In every case they enhance the unique local atmosphere of the places they depict and provide reminders of gentler days in an increasingly busy and frenetic world.

Product Promotions

Frith products are used by many major companies to promote the sales of their own products or to reinforce their own history and heritage. Frith promotions have been used by Hovis bread, Courage beers, Scots Porage Oats, Colman's mustard, Cadbury's foods, Mellow Birds coffee, Dunhill pipe tobacco, Guinness, and Bulmer's Cider.

Genealogy and Family History

As the interest in family history and roots grows world-wide, more and more people are turning to Frith's photographs of Great Britain for images of the towns, villages and streets where their ancestors lived; and, of course, photographs of the churches and chapels where their ancestors were christened, married and buried are an essential part of every genealogy tree and family album.

Frith Products

All Frith photographs are available Framed or just as Mounted Prints and Posters (size 23 x 16 inches). These may be ordered from the address below. From time to time other products - Address Books, Calendars, Table Mats, etc - are available.

The Internet

Already twenty thousand Frith photographs can be viewed and purchased on the internet. By the end of the year 2000 some 60,000 Frith photographs will be available on the internet. The number of sites is constantly expanding, each focussing on different products and services from the Collection.

The main Frith sites are listed below.

www.francisfrith.co.uk

www.frithbook.co.uk

See the complete list of Frith Books at:

www.frithbook.co.uk

This web site is regularly updated with the latest list of publications from the Frith Book Company. If you wish to buy books relating to another part of the country that your local bookshop does not stock, you may purchase on-line.

For further information, trade, or author enquiries please contact us at the address below:
The Francis Frith Collection, Frith's Barn, Teffont, Salisbury, Wiltshire, England SP3 5QP.
Tel: +44 (0)1722 716 376 Fax: +44 (0)1722 716 881 Email: uksales@francisfrith.com

See Frith books on the internet www.frithbook.co.uk

TO RECEIVE YOUR FREE MOUNTED PRINT

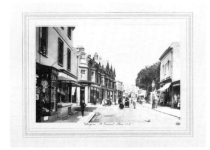

Mounted Print
Overall size 14 x 11 inches

Cut out this Voucher and return it with your remittance for £1.50 to cover postage and handling, to UK addresses. For overseas addresses please include £4.00 post and handling. Choose any photograph included in this book. Your SEPIA print will be A4 in size, and mounted in a cream mount with burgundy rule lines, overall size 14 x 11 inches.

Order additional Mounted Prints at HALF PRICE (only £7.49 each*)

If there are further pictures you would like to order, possibly as gifts for friends and family, purchase them at half price (no additional postage and handling required).

Have your Mounted Prints framed*

For an additional £14.95 per print you can have your chosen Mounted Print framed in an elegant polished wood and gilt moulding, overall size 16 x 13 inches (no additional postage and handling required).

*** IMPORTANT!**
These special prices are only available if ordered using the original voucher on this page (no copies permitted) and at the same time as your free Mounted Print, for delivery to the same address

Frith Collectors' Guild

From time to time we publish a magazine of news and stories about Frith photographs and further special offers of Frith products. If you would like 12 months FREE membership, please return this form.

Send completed forms to:
The Francis Frith Collection, Frith's Barn, Teffont, Salisbury, Wiltshire SP3 5QP

Voucher for **FREE** and Reduced Price Frith Prints

Picture no.	Page number	Qty	Mounted @ £7.49	Framed + £14.95	Total Cost
		1	**Free of charge***	£	£
			£7.49	£	£
			£7.49	£	£
			£7.49	£	£
			£7.49	£	£
			£7.49	£	£

Please allow 28 days for delivery *** Post & handling** £1.50

Book Title **Total Order Cost** £

Please do not photocopy this voucher. Only the original is valid, so please cut it out and return it to us.

I enclose a cheque / postal order for £
made payable to 'The Francis Frith Collection'
OR please debit my Mastercard / Visa / Switch / Amex card

Number .

Issue No (Switch only)Valid from (Amex/Switch)

Expires Signature

Name Mr/Mrs/Ms .

Address .

. .

. .

. Postcode

Daytime Tel No . Valid to 31/12/02

The Francis Frith Collectors' Guild

Please enrol me as a member for 12 months free of charge.

Name Mr/Mrs/Ms .

Address .

. .

. Postcode